BLURTON
THROUGH TIME
Alan Myatt

AMBERLEY PUBLISHING

Acknowledgements

Pat Lancett, John Sargeant, Olive Throley, Ernie Wright, Nancy Carr, Carole Brown, Dave Donkin, John Pointon, Jonathon Dutton, Harry Lockett, Bll & Robinson, Stoke-on-Trent City Archives, Keele University special collections. And my wife Glynis for patiently typing my scribble. apologies to anyone I have missed.

First published 2013

Amberley Publishing
The Hill, Stroud, Gloucestershire, GL5 4EP
www.amberley-books.com

ISBN 978 1 4456 1746 6 (print)
ISBN 978 1 4456 1753 4 (ebook)

British Library Cataloguing in Publication Data.
A catalogue record for this book is available from the British Library.

Typesetting by Amberley Publishing.
Printed in Great Britain.

Introduction

I am a Blurton boy through and through – break me in half and I have Blurton written like a stick of rock. I spent all my young life there and my childhood has so many happy memories spent with pals playing in the streets and fields, or going for big adventures to places like the white rock, poison pool or Newstead Woods. No one locked their doors; I remember my parents leaving the key on a hook in the outside toilet in case any one came while they were out. You could go along the street and name every family. If you got into trouble the Gestapo would tell your parents before you made it home, resulting in a thick ear. I left Blurton when I married and went to live at Fenton. It was like going to the dark side of the moon; I couldn't wait to return home.

Blurton was always agricultural, originally created out of the waste by the religious house at Trentham, which was attracted by the freshwater springs of Cauld Well and Blore Well, the latter giving its name to the village. The priory at Trentham was dissolved by King Henry in 1537 and the brothers were cast out to earn a living as best they could. One was fortunate enough to be engaged by the De Bloretons, who wished him to pray for their souls, eventually causing a small chapel to be built on the high ground above the Blore spring, from where he conducted his ceremonies. A little church has stood in Blurton for over 460 years and it still has a country feel about it, while all around it the world has changed beyond recognition.

The people have changed too. Gone are the days when you greeted neighbours with a cheery 'good morning' and you knew the names of every person. Blurton now is a place of strangers. Things began to change in 1919 when the Duke of Sutherland sold off his estate. Change accelerated rapidly when the council built giant estates to house the newcomers who came to work in the collieries. Just 100 years ago Blurton was very different, as I discovered in a letter written by a church school pupil to her teacher in 1904:

Dear Governess,

I am writing to tell you what I saw yesterday when all the elder children went a walk with Mr Sandford, we started from school just after half past one o' clock. When we got to the square, we met with Miss Hutchinson who was going to Barlaston, so she came along with us. We went along Barlaston Lane and down by Mr Holdcrofts farm and passed over a small stream called the Hem, from which Hem Heath is named after. The violets were lovely and the Newstead wood was blue over with bluebells, we passed over a bank in the wood which is the boundary between Trentham and Barlaston. Then Mr Sandford took two or three of us to measure the large oak tree which is perhaps 1,000 years old. The bottom of the tree is like a saucer turned upside down. Round the bottom of the tree it measured 33 feet and round the trunk 18 feet. The trunk was hollow and inside was growing a young Ash tree, it was very interesting. We went and left our coats at the farm and went through New Park to the lock. We were passing over the railway and saw an express train. When we came to the lock there was a boat coming along the canal and it was very lucky, for we might have stayed a long while and never had seen a boat. When the boat was near us, the man ran onto the front and unlocked the bottom gates and let the water out, then the boat came into the lock. When the boat got in, the man unlocked the top gate, and as fast as the water came in, the boat rose up, then the boat went on its way along the canal. We then returned to the farm and had buns and milk which we all enjoyed. We then gathered some forget me nots which were plentiful in the woods. We had games on the swings and then came home. I enjoyed myself very much, but was very sorry you were unable to come. We must thank Mr Sandford for taking us.

Your Affectionate Scholar.

Martha Colclough.

I can't promise to take you back to those halcyon days, but I can show you how massive change has taken place in Blurton since Victorian times. My yearning for the old days was stirred by photographs left by my grandfather, which have been swelled by donations from Blurton old timers. After having the photographs for many years, I decided it was time to share the pictures of this little corner of old England with you.

Walk the circular route, but take the book with you and see what you can discover. Join me on a journey in *Blurton Through Time*.

Alan Myatt

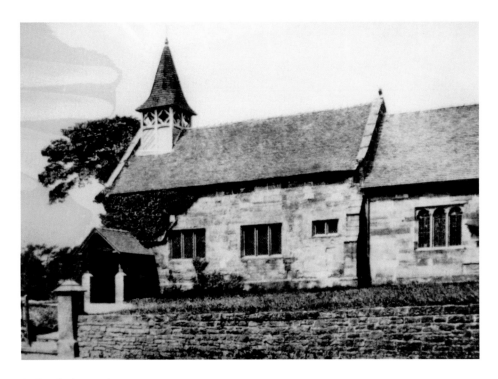

St Bartholomew's, 1900

St Bartholomew's is thought to have been a private chapel for the De Bloreton or Colclough family and dates from around 1553. The first written evidence is 'Blurton Chappel' marked on Saxton's map of 1577. In 1626 it was ruinous and rebuilt from a quarry behind No. 96 Church Road. The royal coat of arms over the old entrance was granted in 1629 and is the oldest in Staffordshire, having a faint crest with '16 C. R. 29' at the top. The porch over the south door was added in 1867.

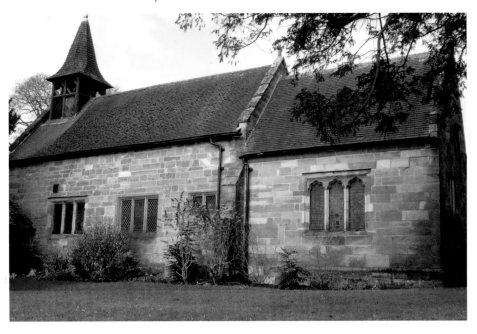

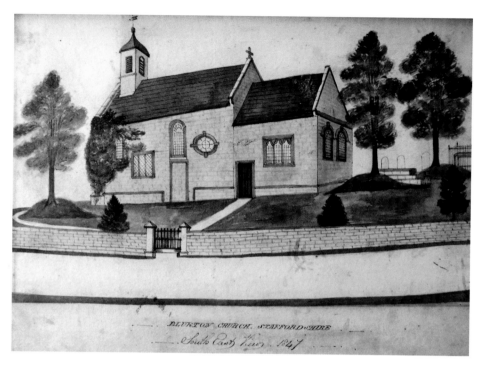

BLURTON CHURCH STAFFORDSHIRE
South East View 1847

Colclough

This ink drawing is dated 1847 with Colclough written on the reverse. It shows how windows and doors have been altered. The snow-covered lychgate below was added in 1925 by Laura Aynsley in memory of her husband John Henry Cunliffe Boardman of Blurton Mill who died 1917 and left a considerable sum to build the Boardman Neurology ward at the Infirmary. The replacement bell cote was designed by Gilbert Scott and has a single bell dated '1722 Abraham Rudhall'.

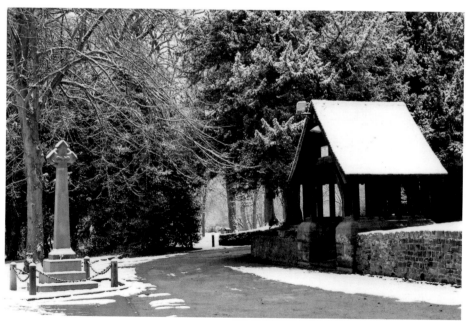

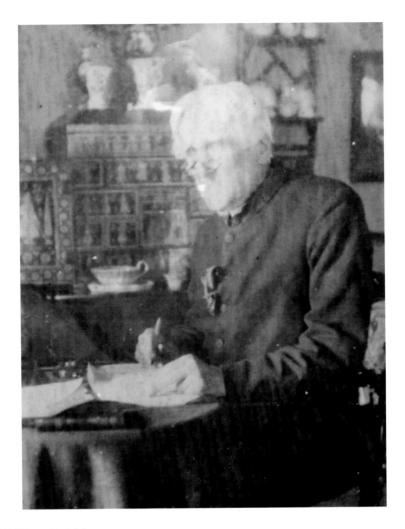

Revd William Hutchinson

'London, 9 July 1910: The oldest clergyman in England died yesterday. Had he lived another seven weeks he would have been 100 years old. On 29 August the Revd William Hutchinson, prebendary of Lichfield Cathedral and vicar of Blurton, delivered a sermon in his tiny, quaint church at Blurton in which he referred to his ninety-ninth birthday, which had fallen four days previously. Many people had come from the villages around to hear him, and he surprised the strangers by his comparatively vigorous appearance and particularly by his strong voice, which seemed like that of a man of forty. It was a touching sermon he delivered, and in it he said it was doubtful if he would be alive a year hence. Mr Hutchinson was greatly respected and beloved. He had been vicar of Blurton since 1865, and in all the years since had hardly ever failed to preach on Sunday morning. He was born on 25 August 1810 at Heavitree vicarage Exeter, his father being the Revd William Hutchinson, then curate of the parish. He was educated at the school of the clergy orphan corporation. From there he went to King Edward School, Birmingham, and in 1828 was elected to a bible clerkship at All Souls College, Oxford, from which he took his degree in 1833. His first curacy was at Dunchurch, and in 1836 he moved to Rotherhithe where he built the church and vicarage. In 1850 he was appointed by the second Duke of Sutherland to the perpetual curacy of Hanford, and in 1863 by the third Duke of Sutherland to the vicarage of Blurton, which he held until his death.' (*New York Times*)

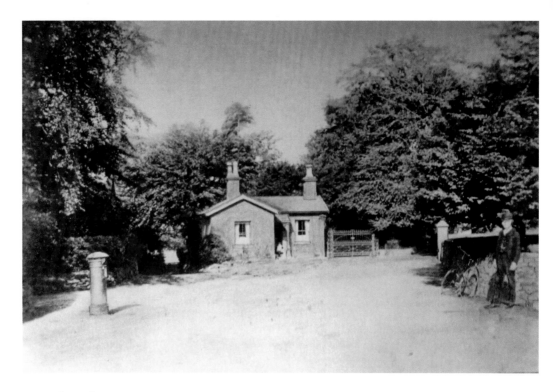

Chappel Green

The area in front of the church was called Chappel Green on Thomas Burton's 1714 map. The lane to the left of the lodge went to Blurton Mill, and the lane to the right led to Blurton Hall and Farm. The ornate gates beside the lodge belonged to Blurton House. The gatepost beyond the cyclist was relocated into the churchyard's north perimeter. Edith Henney was born in the lodge in 1880.

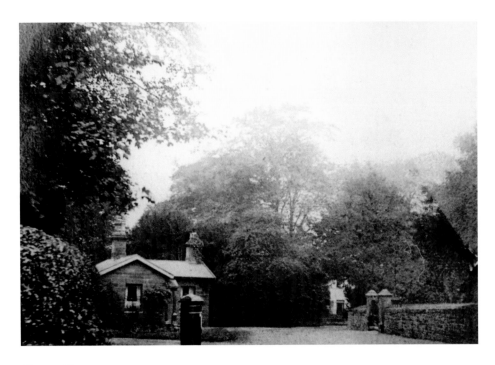

Blurton House

In this earlier photograph, taken from the priory entrance, Blurton House can be seen through the trees, with the village postbox prominent, where countless letters and postcards of sorrow and joy were sent. The lychgate has not yet been built. The lodge was built around 1850 to guard Blurton House. In 1901 William Gilbert, aged fifty-eight, a coachman, lived there.

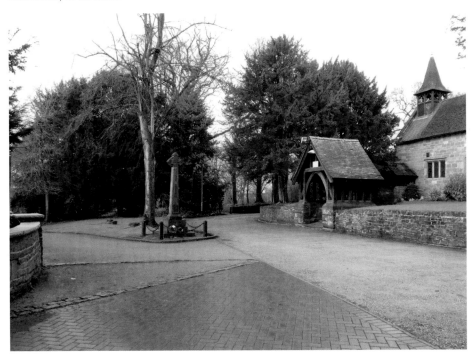

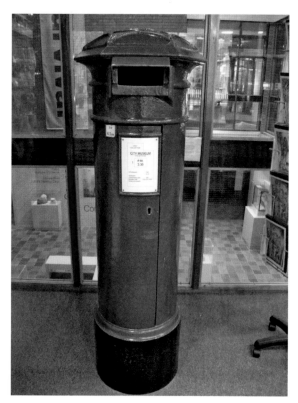

Postboxes

The green Blurton pillar box was a first national standard postbox. It was manufactured in 1860 by Cochrane & Co. at Woodside Works, Dudley. It is one of the oldest in the country and stood from 1860 until 1958 outside the church. Early boxes had no royal cipher and are known as anonymous boxes. Red postboxes appeared from 1874. The replacement lamp box on a post in the churchyard has since been removed and a red GR (George V) box erected in Church Road facing the church graveyard. The original pillar box stands in reception at the Potteries Museum, Hanley, and is still in use.

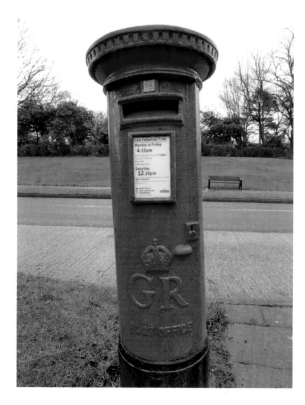

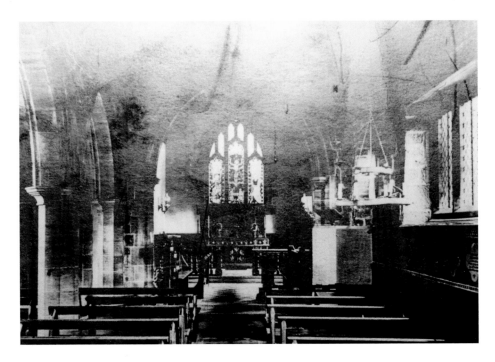

Church Interior

This image of the church interior in 1900 shows oil lamps and a candle chandelier. Open pews had replaced the earlier box pews in 1865; at the same time, the floor was lowered to allow the old south door to be reopened. The open pine pews were replaced with sturdy oak pews in 2011, purchased from a church in Hereford at a cost of £10,000 and more in keeping with this warm and cosy church. Otherwise the scene remains the same.

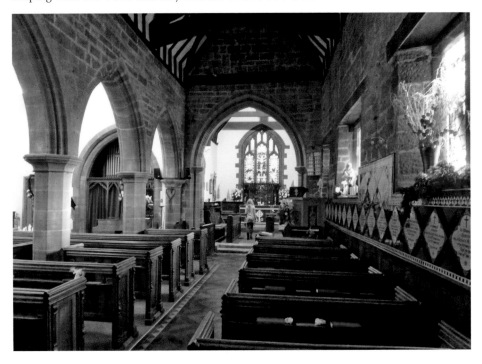

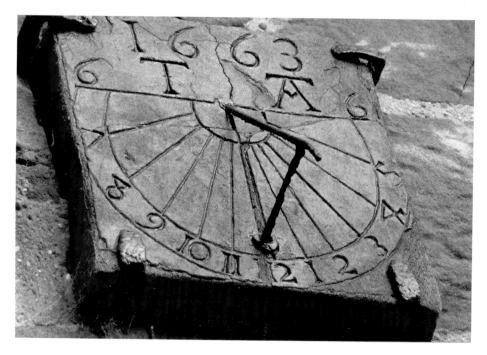

Sundial

To celebrate the restoration of the monarchy, Thomas Adams, curate of Blurton from 1649 (the year King Charles I was executed), erected this sundial. Adams died in 1666. The carved head on the east window is thought to represent Revd Obidiah Lane of Longton Hall, who had the new chancel built in 1750. His son, also named Obidiah, was also priest at Blurton – he married Sarah Crewe of Crewe Hall and moved to Barthomley. The junior Obidiah Lane died of a lingering illness in 1779 and was buried in Chester Cathedral.

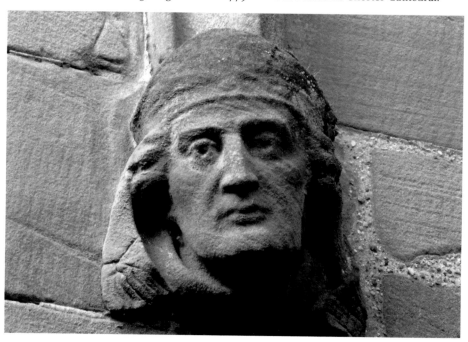

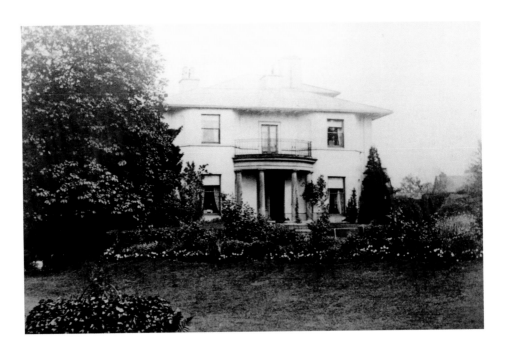

Blurton House

Blurton House was a late Georgian building, built for pottery manufacturer John Harvey in 1822. He married Mary Ann Ford of Newstead in 1807. He died at Blurton House in June 1863, aged seventy-nine, and the house was sold four years later. John Arlidge, physician, was living there in 1871 with a lunatic son. The house then passed back to the Ford family, who lived there until 1902. The last owner was John Gerrard Aynsley, who married John Henry Cunliffe Boardman's widow Laura and moved to a farm at The Spot near Hilderstone.

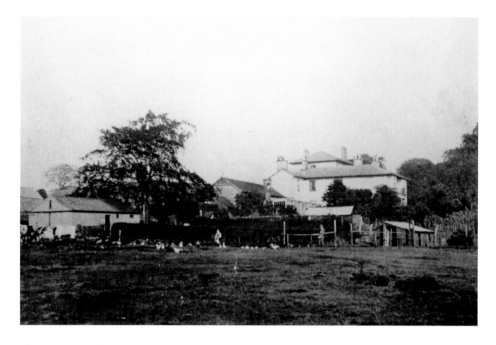

Blurton House from the Meadow

A view taken from across the meadow towards Blurton House shows it as a smallholding. Young Master Aynsley is seen feeding the fowl with local lad Ernest Carr from Barlaston Lane. The peace celebration featured later took place in the meadow to the right of this scene. The photographs are from an album probably taken to celebrate the turn of the century and treasured for many years by the Carr family. A children's play area now sits in the meadow.

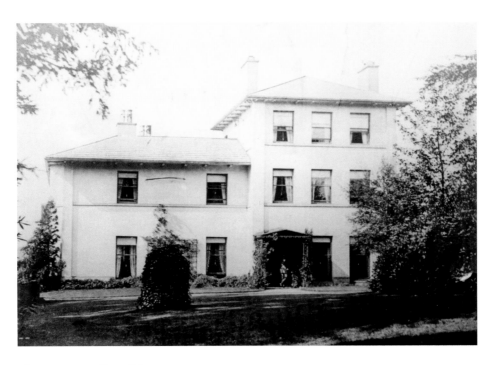

Blurton House, East Side

This is the east side of Blurton House, which is just as impressive as the front. There was a high wall built behind the trees on the right, giving privacy from the lane that went across the fallow field to Blurton Waste Farm. Gerrard Aynsley poses nonchalantly in the doorway. The house was rented out as flats before its demolition in the 1950s. No trace of Blurton House can be found today, except for this earth mound with trees. The lane now leads to Enstone Close.

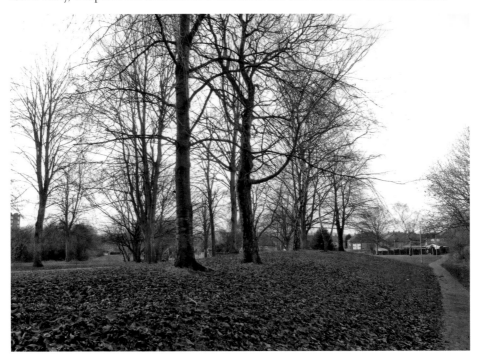

Glasshouse

Here is a rare glimpse into the private world of the home of a pottery manufacturer. Not only did he run a small farm, he also took pleasure in growing exotic plants. The view down the yard towards the millpond shows the heated glasshouse on the left. The interior photograph shows tender plants such as abutilon, jasmine, orchids, sword ferns, Boston ferns, begonia rex, maidenhair fern and tradescantia (known as wandering Jew). There is no sign of tomatoes!

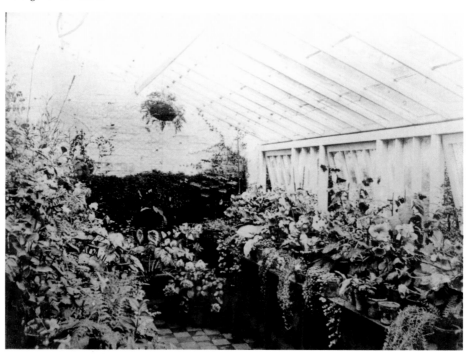

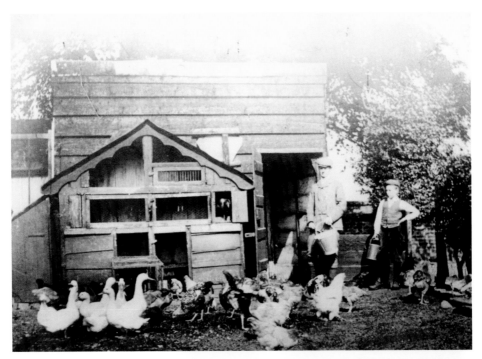

Gerrard Aynsley

A close-up of Master Gerrard Aynsley feeding the fowl in the meadow below Blurton House, assisted by young Ernest Carr. Gerrard was born in 1880, the grandson of well-known china manufacturer John Aynsley. He joined the Cheshire Yeomanry, which was called upon to assist in the Boer War, arriving in Cape Town, South Africa, in February 1900. He was awarded the Queen's South Africa medal and married the young widow Laura Boardman from the mill next door. Ernest grew into a fine young man, working at Florence Colliery. He is shown in the photograph on the right.

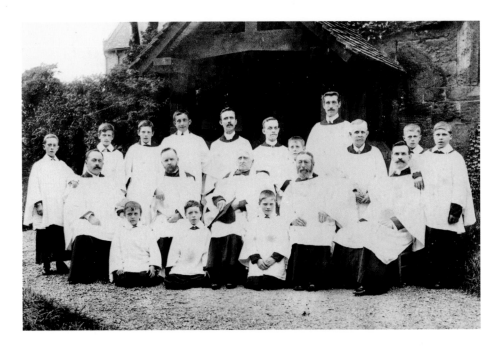

Church Choir

Blurton church choir, 14 July 1906. The photograph cost 2s unframed or 3s 6d in a polished oak frame. The choir members were, from left to right: Albert Wright, John Powner, James Powner, -?-, -?-, -?-, William Carr, ? Elkin, William Elkin, A. V. Reynolds, Sandford Hutchinson, William Hutchinson, Charles Carr, Albert Carr, Harold ?, Wilf Johnson, William Hancock, ? Middleton, Ernest Carr. Below is the church choir on 30 December 2012, who kindly gathered for the photography shoot. Space does not allow for all their names.

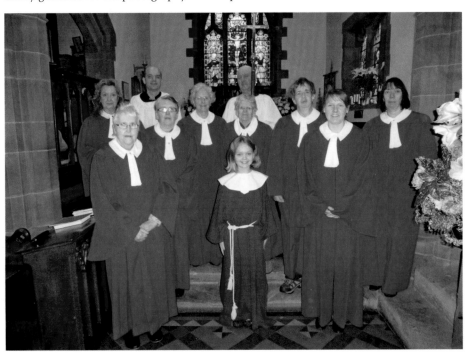

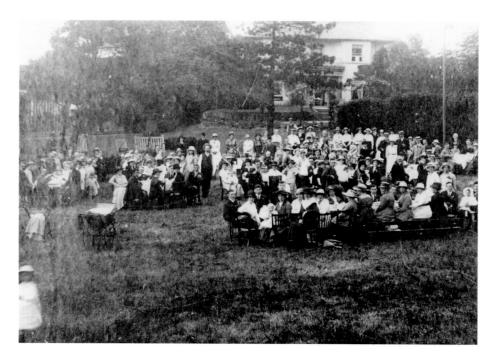

Peace

An extremely rare picture of a peace celebration. It was taken at Blurton in June 1919 in the sports field, kindly lent for the occasion by Mrs Boardman from the mill. Each child received a decorated mug from her. Others sat down to a capital knife-and-fork tea in the meadow, lent by Mr Aynsley of Blurton House. A huge bonfire was lit at dusk. Below is a photograph showing war survivor Arthur Tomlinson, of Crown Cottage. He is second from the right in the back row of this group of soldiers billeted with a French family.

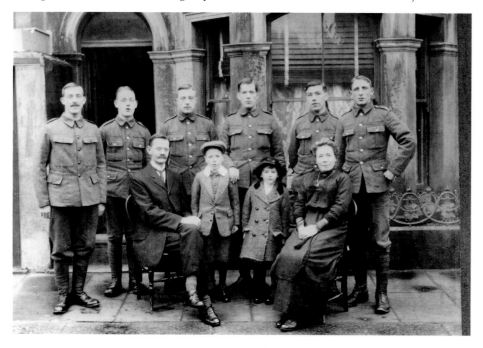

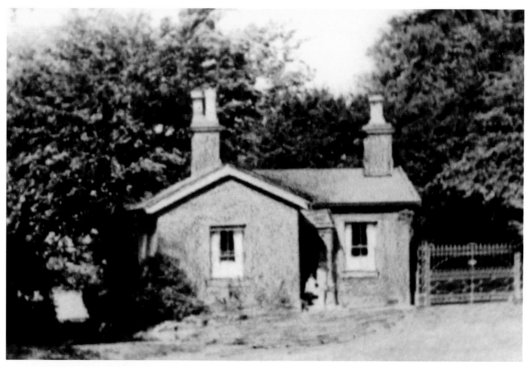

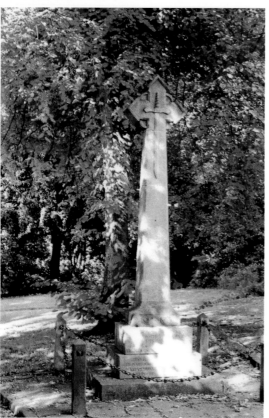

Blurton House Lodge

This tiny lodge guarded Blurton House and only had two small rooms. Ernest and Olive Thorley lived there until 1953. Ernest had been in the RAF. He erected a wire as a radio aerial at the lodge, but the farmer at Blurton Farm complained that it turned his milk sour! The war memorial erected after the First World War now stands alone. It lists nine Blurton names: Ronald Aynsley, George Bassett, Harry Bates, Albert Carr, Charles Carr, William Egerton, Leonard Johnson, William Middleton and Samuel Poole. Egerton's brother survived and was awarded a Victoria Cross.

Blurton in the Snow

A snowy picture, taken by the local newspaper in January 1936 after a very heavy snowfall. The newspaper described Blurton as a village on the outskirts of the Potteries. The walkers are struggling along the lane from Enstone Close, with the high wall and Blurton House on the left. The lane still exists as a shortcut to the church, though Blurton House and the wall have been obliterated.

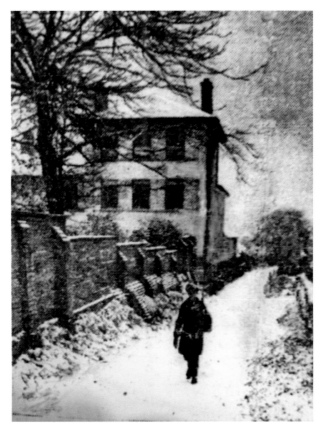

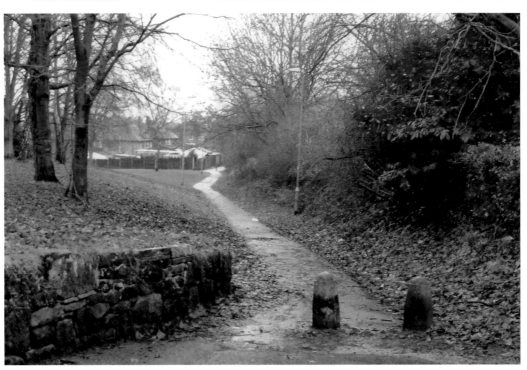

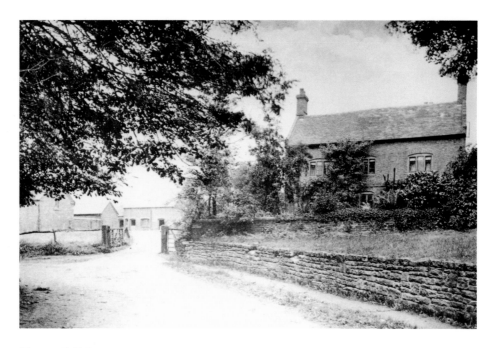

Blurton Hall Farm

Blurton Hall Farm is seen here in 1919. It was rebuilt by the Marquis of Stafford in 1817, and was described as a dairy farm with 73 acres. The farmhouse has since been replaced. For many years the outbuildings were used by the parks department to store equipment. When electricity was connected to the farm in 1935 the farmer refused to use it, saying it was unhealthy. A builder bought the land recently only to find that the access road was private, belonging to the church.

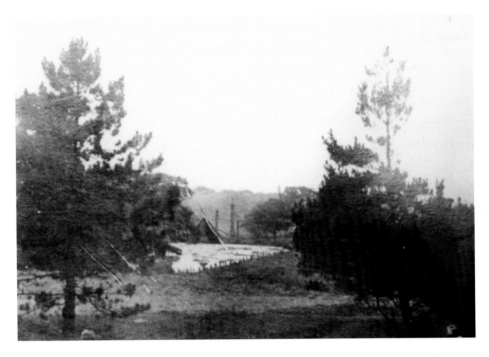

Blurton Colour Mill

This is the only known photograph of the colour mill. It dates from 1900, and was taken from Blurton House looking across the millpond. The fir tree on the left has survived and is now a giant, while its twin has disappeared. The modern view is obscured by undergrowth, but the area is still picturesque, with freshwater springs bubbling up to feed the millpond, as they have for many centuries.

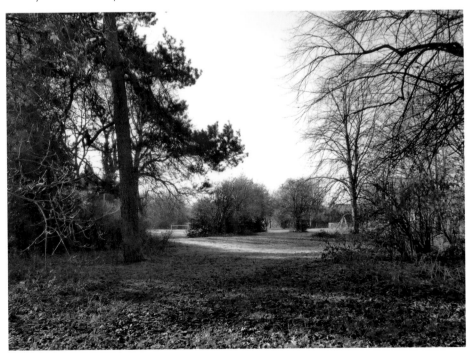

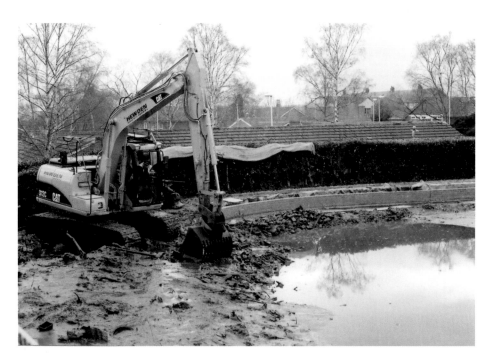

The Millpond

In March 2009 it was decided to regenerate the millpond, and a temporary dam was constructed to stem the flow of the freshwater springs. The water was diverted to one side to allow dredging. Around 200 years' worth of silt was removed from the pool, along with supermarket trolleys and numerous bikes and wheels. Hundreds of bricks from the old mill were discovered and removed, and a new retaining wall was built to hold back the pond. Two giant pike were rescued during the operation, and the resident swans were delighted.

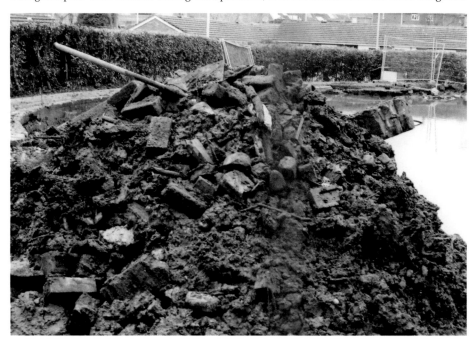

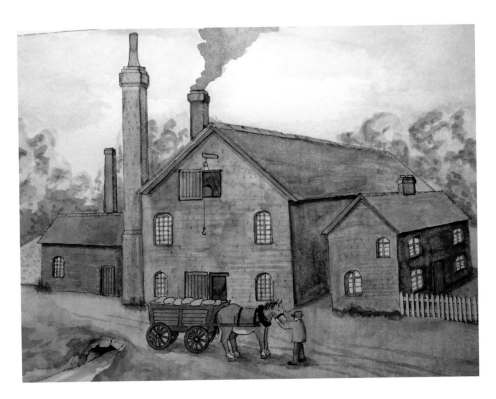

Blurton Colour Mill

Only one actual image of Blurton colour mill survives (*see page 23*); this is an artist's impression. A mill was first recorded on a map of 1809 and again on Fulton's map of 1815. The Blore Well was dammed to feed the corn-mill wheel. The mill was converted to a colour mill in 1836 and worked by Henry Boardman. His son William took over in 1860, becoming wealthy as a result of inventing Boardman's maroon, crimson and du barry gold. The mill fell out of use in the 1950s and was converted into flats before its demolition. Senior citizens' bungalows now occupy Poolside.

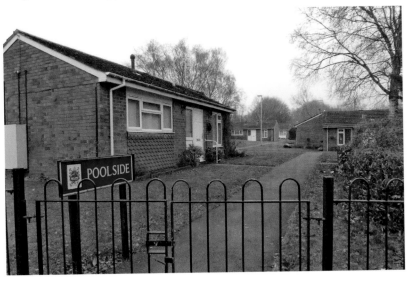

Ripon Road

Ripon Road was constructed in 1926 to allow better access to the colour mill. These single-person flats were built in 1955 to house professional men and women who were out all day. In one block of flats electric underfloor heating was installed. The flats were let out at an economic rent, those with underfloor heating costing an additional 9s per week. Boxall's Café Royal garage stood at the junction with Trentham Road. The two petrol pumps have long disappeared, as has the air-raid siren that stood in the garden.

Colour Mill lane

Another newspaper photograph of the heavy snowfall in January 1936. It shows men clearing snow from the old Colour Mill Lane opposite the church. Blurton House Lodge has disappeared, but otherwise the scene has changed very little. The lane is now a footpath beside the millpond to the multistorey flats of Pedley and Robinson Courts off Ripon Road.

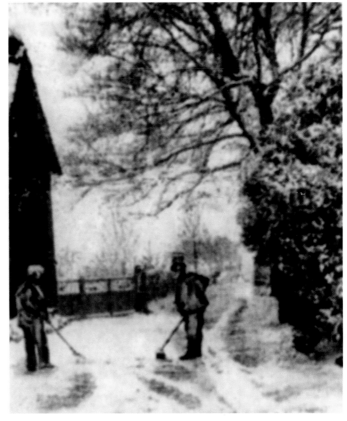

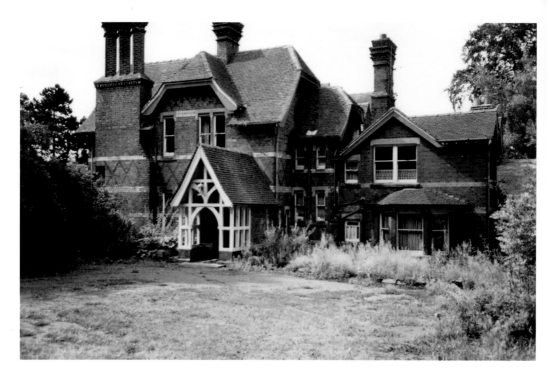

Blurton Priory in 1989

In 1633 John Keeling, brother-in-law to George Colclough, gave the land where the Priory was built as a gift to provide a perpetual income for the priest. On the site were a house, cottage and two gardens. The curate's house and offices that stood there were demolished and rebuilt by Charles Lynam in 1867 at a cost of £15,000. All were demolished in 1992 after having stood ruined and empty for some time following a fire. A new mansion estate was built there in 1999.

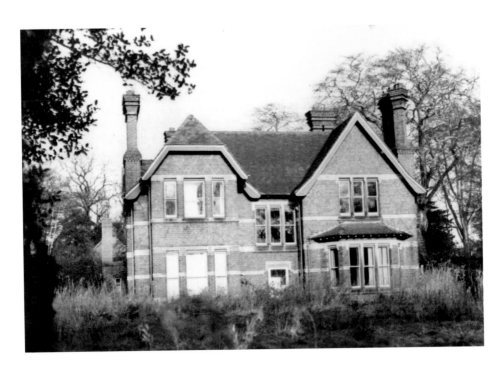

The Priory Well
The rear of the Priory as it appeared in 1989 is reflected in the design of the new house built on the site in 1999. The Priory well was discovered in the garden during the construction of this house. The Priory was sold in 1921 when the vicar went to live in Blurton Green farmhouse. He moved into the new vicarage off School Lane in 1927. The last owner of the Priory before it fell derelict was Mr Percy Cooper, managing director of Taylor & Tunnicliffe.

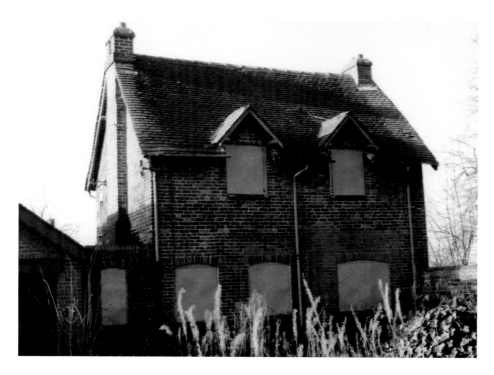

Priory Cottage

This building was known Priory Cottage and home to the coachman to the curate at the Priory. This image was taken in 1984 when the cottage was out of use. There has been a house on this site since 1714. By 1936 it was home to Eric and Gladys Burnett. Luckily this cottage survived the fate of the 'big house' to which it was attached, and today it is a pleasant and desirable property off what was Chappel Green.

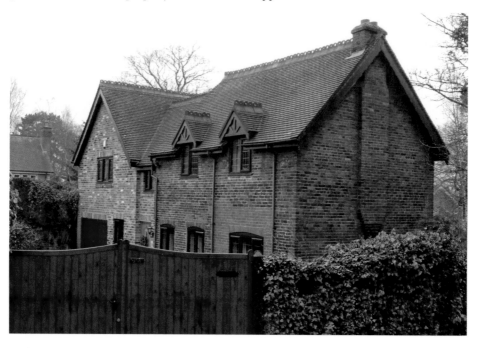

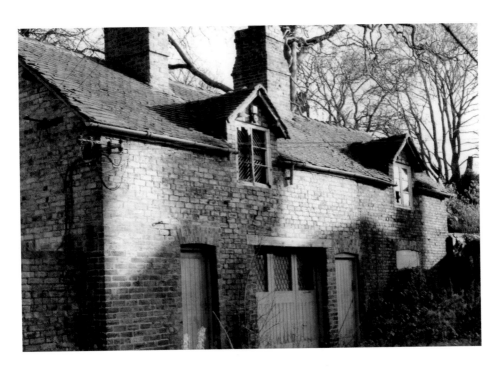

Coach House and Tack Room

The coach house and tack room facing Priory Cottage are in a sorry state in this 1984 photograph. The phaeton would have been housed here, awaiting the call from the curate when he wished to venture out on business. Horses would also be kept here in inclement weather, with hay and straw in the loft above. The windows had diamond-shaped leaded glass. A large rookery in the giant beech trees behind disappeared when modern street lighting was installed. Also rescued, this cottage stands behind secure gates in what was the side entrance to the Priory.

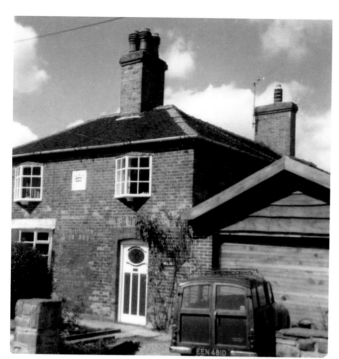

Hollydene
The grand old lady of Blurton village, 1977. Hollydene was a small cottage. In a bad state of repair, it was demolished and rebuilt by the Marquis of Stafford in 1823. His coronet is proudly displayed on the front of the cottage. It was occupied by Joseph Proctor from 1832. He was a cordwainer, born around 1772. Walter and Florrie Ray lived here in 1940; the house was very damp at this time. The large garden was later sold off and new houses were built along the brow of the hill on Church Road. The mellow red brick has been covered over now.

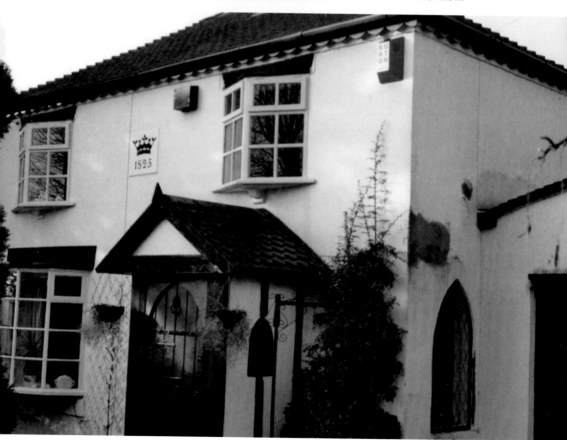

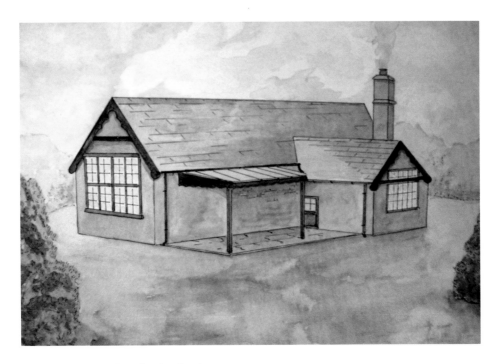

Blurton Church of England School

A painting of Blurton School. It was built in 1895 to accommodate the number of pupils grown too large for the old cottage church school behind Hollydene. It was very basic, with earth closets that were emptied onto the vicarage garden, and it was heated by a single pot-bellied stove. Pupils had to walk miles over the fields from Cocknage in all weathers to attend. In 1938 it became Blurton Church of England Infants' School, but closed in 1959. It was demolished in 1974 and new houses were built on the site in School Lane.

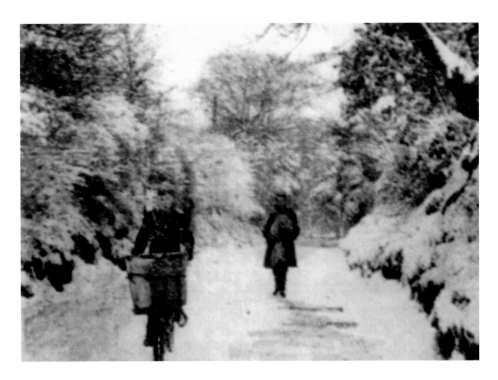

School Lane in the Snow

Another view of the heavy snowfall of January 1936, this time a sketch of School Lane. This ancient, hollow lane was the main thoroughfare through Blurton Village to Trentham. It became a quiet country lane with the completion of Trentham Road, which bypassed the village. When the graveyard became full, a new extension was built off School Lane, which is also now full. Below is a photograph of a snowy scene, taken from the same location in 2009.

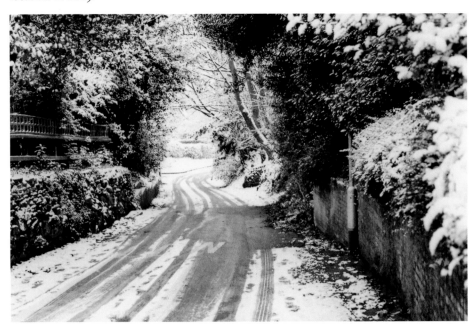

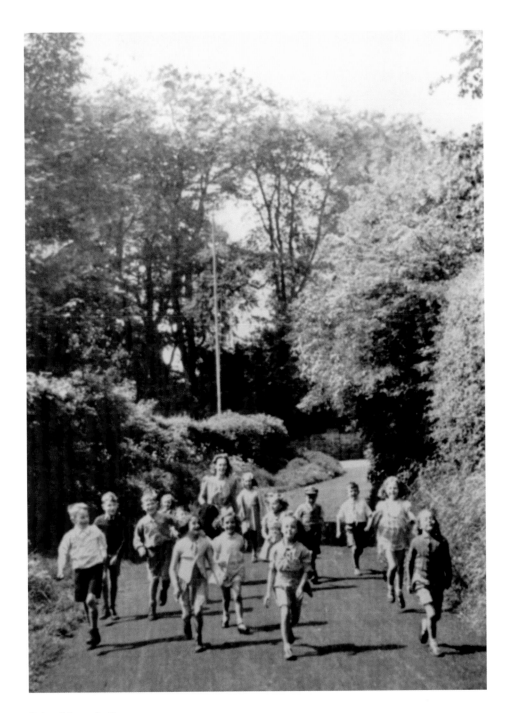

School Lane in Summer, 1953

This happy picture lifts the heart. It shows a bright summer's day in School Lane, with happy, smiling schoolchildren on their way to lessons with their teacher. The photograph was taken in 1953, when there was no need to worry about traffic and the skies were always blue. Where had they been? Perhaps down to the church, or to have a look at the swans on the millpond? I bet all the children's parents were in employment and life was never better. Where are they now?

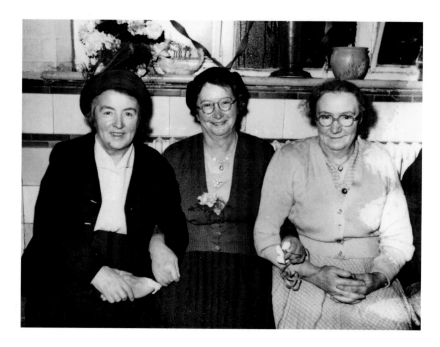

The Tomlinson Sisters

These are the Tomlinson sisters – Annie, Mabel and Olive – who lived at Crown Cottage. At school Olive and her brother Arthur were punished on 4 September 1901 for throwing stones. Olive was caned again in May 1904 for untruthfulness. She never once saw the sea. The picture was taken in 1955 at their old school in School Lane. Behind Hollydene is a modern bungalow. It is on the site of an old cottage, which dated from 1827. It became Blurton's first Sunday school in 1839, and then a day school from 1872. It burnt down 1886, but the shell was saved and became a free school in 1891.

Tollgate House, 1960
Known to many as the Gingerbread House, Tollgate House was sited at the junction of Barlaston Lane and Trentham Road. It was built in 1771 to collect tolls from all vehicles on the new turnpike road; only Royal Mail coaches were exempt. The last family to live in Tollgate House was the Wright family. It was demolished in 1963. The staggered crossroad has been realigned, so that the house would have stood on what is now the grassy island by the traffic lights.

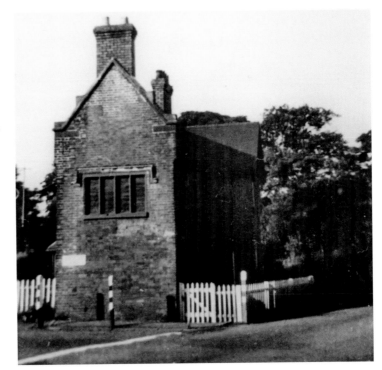

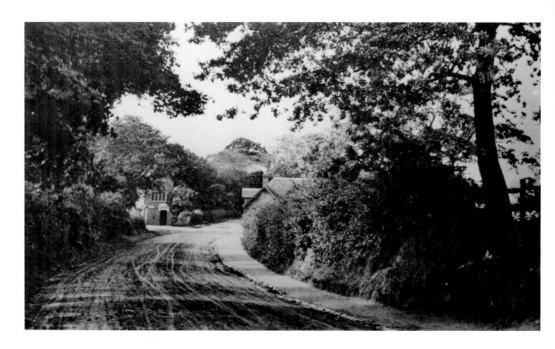

Tollgate

An early 1900 view of Tollgate shows Blurton at its best. The cottage on the right was demolished in 1955, its last occupant being a smartly dressed West Indian gentleman named Mr Magaki, who worked at Hem Heath Colliery. Despite Tollgate being called the Gingerbread House, gingerbread was actually sold across the other side of Trentham Road in the aforementioned cottage. Only the old oak tree from its garden survives, on a small garden plot at the end of Church Road.

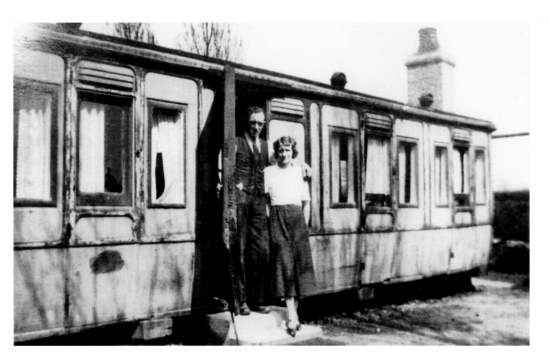

Living in a Railway Carriage

Another very rare photograph; it depicts the half of a railway carriage that was made into a home due to the chronic housing shortage after the war. The other half stood in a field along Barlaston Lane and was in use as a cowshed. Sidney and Lily Wright are the couple standing proudly in the doorway. Several other families lived in the carriage before they were rehoused on the new council estate. The carriage stood in a field behind Tollgate House where this electricity substation has since been built.

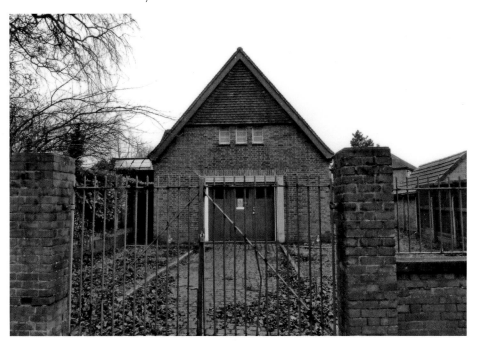

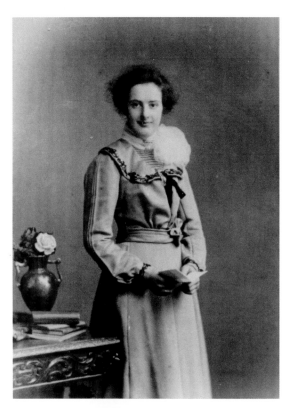

Cottages

Emma Carr; her brothers Charles and Albert were killed in the First World War. She married Samuel Barnett and lived in the middle one of the three cottages below. Her parents lived in the cottage on the right-hand side. In the left-hand cottage an old lady made gingerbread and brandy snaps, which she took to be sold at the crossroads on Trentham Road. Emma died in April 1955 and her husband passed away on the day of her funeral. The Cauldwell Spring bubbles from the ground behind the cottages, which later became Critchlow's chicken farm.

Rose Cottage

Harriet Carr sits in the yard of her home, Rose Cottage in Barlaston Lane, in 1928. She was Emma's mother. Notice the rolled up handmade peg rug, made from pieces of cloth forced through a piece of sacking with a clothes peg, only the rich could afford carpets. Her husband Charles was a senior member of the church choir and worked as a domestic gardener on Newstead Farm. Harriet's son Ernest married Olive Tomlinson from Crown Cottage, which was almost opposite Rose Cottage. The fields across the road were abundant with watercress, which grew in the flow from Cauldwell Spring.

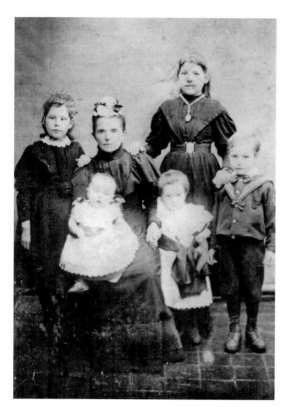

Crown Cottage
A Victorian image of the Tomlinsons. The family moved around with the farmhand work of their father. Born in Fulford, Caroline, Annie, Olive, Lizzie and Arthur pose here with their mother Elizabeth. Head of the house Joseph worked as a cowman on Newstead Farm. Their home, Crown Cottage, was demolished when the farm was compulsorily purchased to build the council estate. They moved to Oulton, Stone. The first house after Waterside Drive was the site of Crown Cottage.

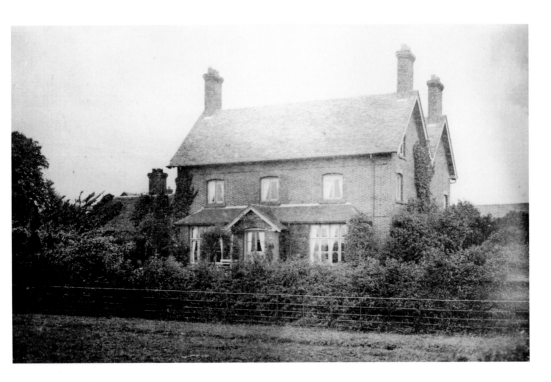

Newstead Farm, 1919

At this time, the Trentham Estate had put the farm up for sale. The area was known as Cauldwell until the time of Henry VIII, when the new homestead was built. It was rebuilt by the Marquis of Stafford in 1813. His land agent insisted on improvements to farming methods, and farmer Richard Ford was considered an ideal tenant, but later they quarrelled over rents and Ford left. The farmhouse was made into the Swallows Nest pub in the 1950s.

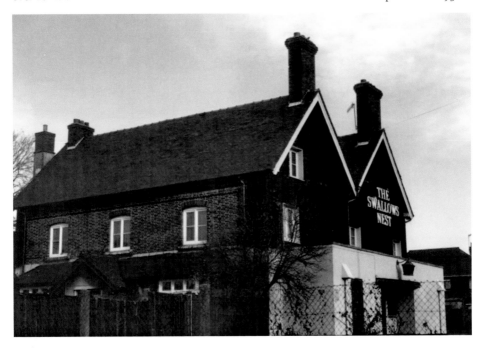

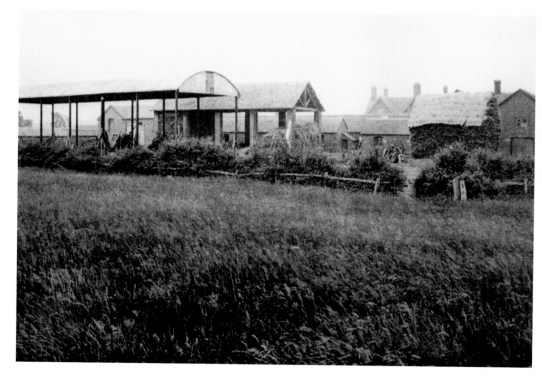

Newstead Farm Buildings

In 1919 the farmer was Timothy Holdcroft. The farm consisted of 343 acres of land with five cottages attached. There had once been a corn threshing mill on the Hem Brook, where later the Old Mill working men's club was built. The club was burned to the ground in 2012. Crystal clear water from the Cauldwell emerges from a pipe nearby. The Swallows Nest pub stands derelict, having been sold to a builder in 2012.

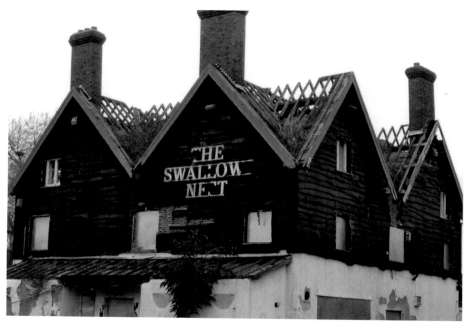

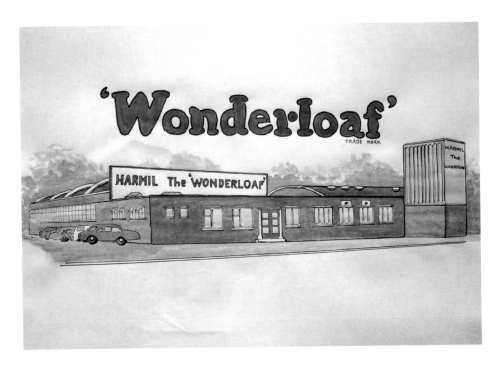

Bakery

An advertisement for the Wonderloaf Bakery on its opening day, 21 June 1961. The business had first been established by Harry Mills at Normacot in 1903. The new Newstead Bakery was built by G. Percy Trentham. The first factory unit on the estate, the site had previously been occupied by a weaving factory owned by J. R. Holbrook & Son. In 1958 Harmil became part of the United Bakeries and merged with Walters Bread of Fenton. Harmil bread has disappeared from the marketplace, and the bakery has been made into small factory units.

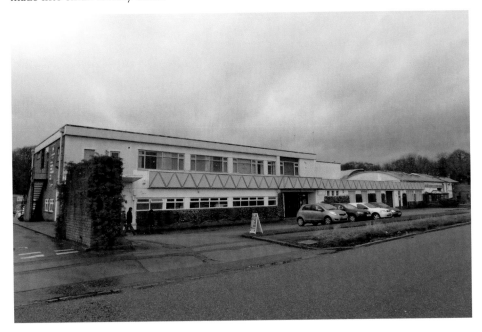

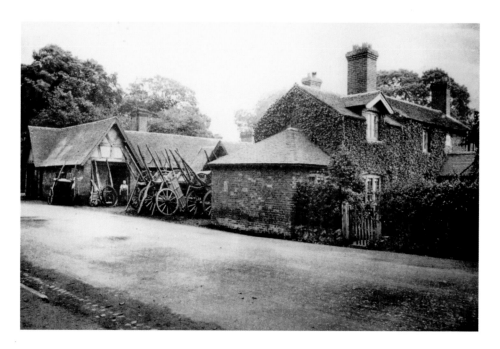

The Blacksmith

The blacksmith at Hem Heath was next to the canal wharf. In 1851 it was worked by James Batkin, aged sixty-two. He had a young apprentice named Godwin Embrey, who was aged eighteen and from Fenton. This young lad went on to start Embrey's Bakery in King Street, Fenton, as well as working the post office there. His hard work paid off and the family became wealthy. The photograph was taken in 1919 when the blacksmith's was worked by the Walklate brothers. One was a blacksmith and the other a wheelwright. Today the site is occupied by a modern BP service station.

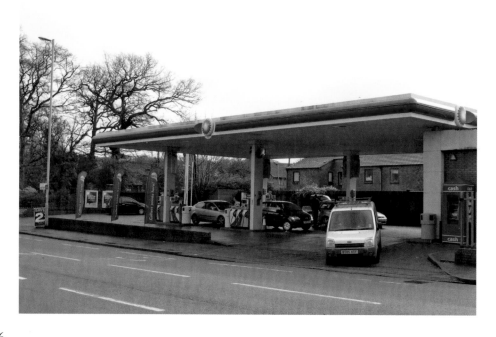

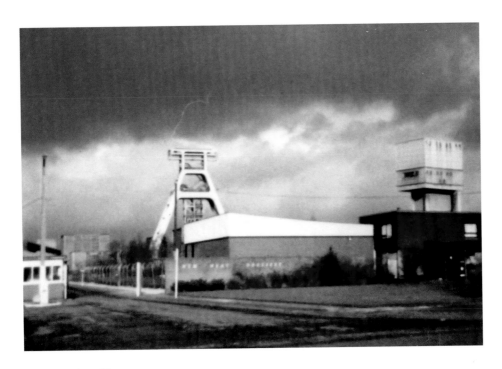

Hem Heath Colliery

The first sod for Hem Heath Colliery was cut in July 1924 by the Duke of Sutherland. When sinking No. 1 Shaft, a fast-flowing underground stream was encountered that had to be frozen to allow progress. Notice the lightning strike captured on my photograph. On 19 August 1997 the landmark A-frame was toppled by explosives, signalling the end of coal mining at Hem Heath. Methane gas is extracted for the national grid from below the new estate built on site.

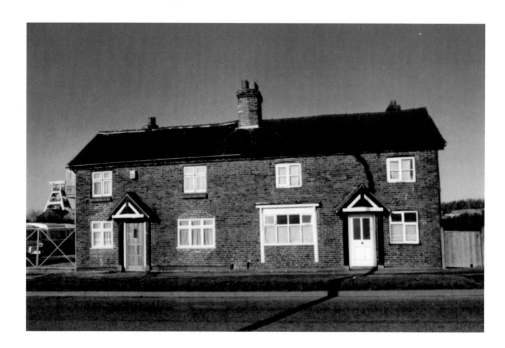

Hem Heath Cottages in 1977

Hem Heath Cottages were twins with the Hem Brook Cottages found up the road. They were built in 1733 on the edge of Hem Heath by Granville Leveson Gower of Trentham for his workers. The cottages had a large extension added on the back by his descendant, the Duke of Sutherland. During the Second World War the cottages were converted to premises for the Midland Bank, but it was never used. The frontage for the bank was left in place, as can be seen above. The old bank was a nursing home for a short while.

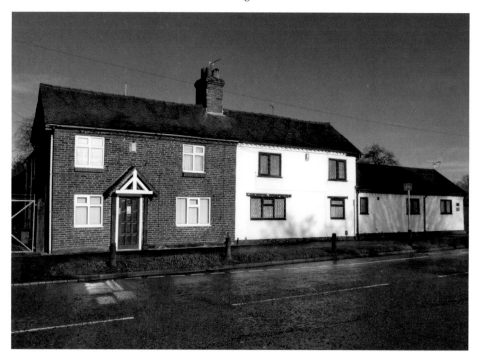

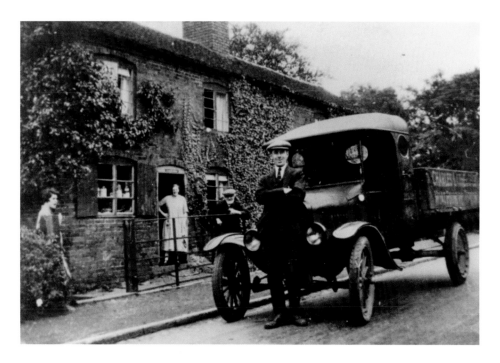

Polly Powner's Shop

The shop was at Hem Brook Cottages. In 1901 it was home to William Powner, who had three sons and a daughter, Mary, known as Polly. The Powners originated from Beech. The proud vehicle-owner is Harry Powner of Beech sawmills. Polly married Benjamin Rhead, a farmhand from the Waste Farm. In 1953 they retired to Meliden, North Wales, where they died and are buried. Polly's niece Olive Thorley moved from Blurton House Lodge into Hem Brook in 1953.

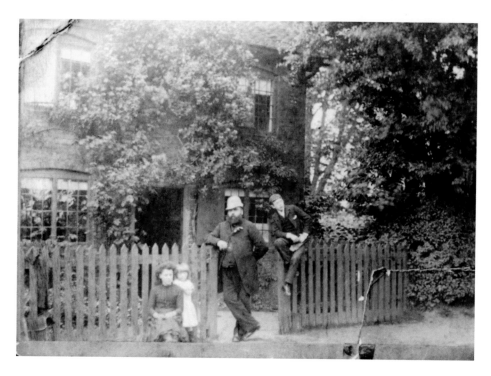

Hem Brook Cottages, 1980

A very early image of the other half of Hem Brook Cottage. Pictured are George Wade and his daughters, Aggie, who married Albert Wright, and Phyllis, who married Benjamin Rhead's brother Charles. The youth sitting on the fence is thought to be Benjamin. Water was obtained from the Blore Stream, which ran from the millpond, past the back door and into the Hem Brook down the meadow. The earth closet still stands behind the cottages.

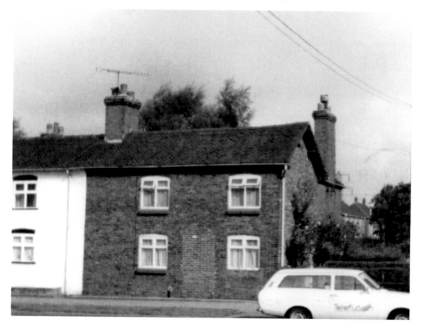

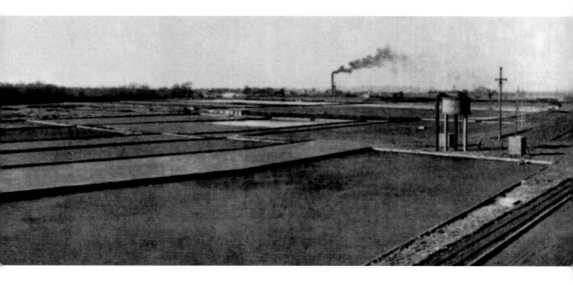

Sewage Farm

Stoke-on-Trent's boundary was extended in 1922 because the land was needed for sewage sludge treatment beds; the existing Waste Farm had become overwhelmed. The 30-acre site dried out the sludge on ash filter beds then allowed it to harden in the sun. The cake was then pulverised into organic manure and sold as fertiliser. A wet mixture was sprayed onto old pit mounds to encourage plant life. The tall chimney behind is that of Hem Heath Colliery. The sewage farm is now a Biffa waste site.

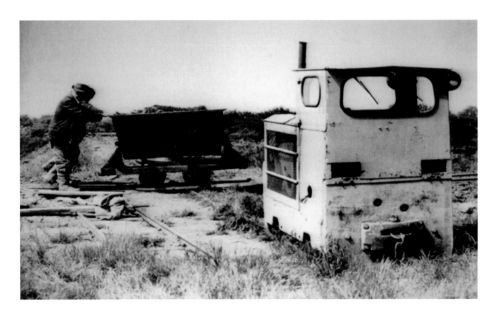

Newstead Works

The dried sludge cake was lifted with wide hand forks into tipper trucks, above, transported via a portable light railway track in groups of three to a tip. The trucks were pulled by a Lister petrol locomotive, built for Newstead Works in 1944. The locomotive served until the Newstead Works closed in 1977. It then moved to serve at Burslem Sewage Works until it was retired in 1983. It has since been restored and now runs at the Ecclesbourne Valley Railway Museum near Wirksworth, Derbyshire.

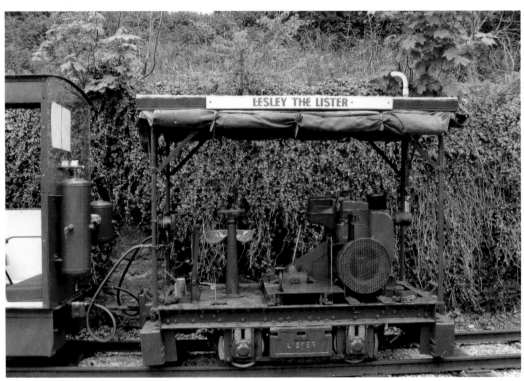

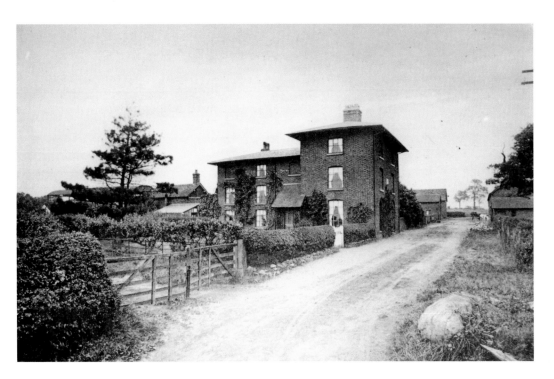

Blurton Waste Farm, 1919

The farm was built in the common country style in 1811. It was called the Waste Farm because it was built on waste ground; it was coincidence that it was later used as a sewage farm. The farm track led to Meadow Lane, Trentham, until the railway arrived in 1848 and a new farm drive had to be constructed onto Trentham Road. The track continued along to Blurton Tilery. Both the farm and the tilery are now gone, but the track remains as a very pleasant walk between Trentham Lakes and the council estate.

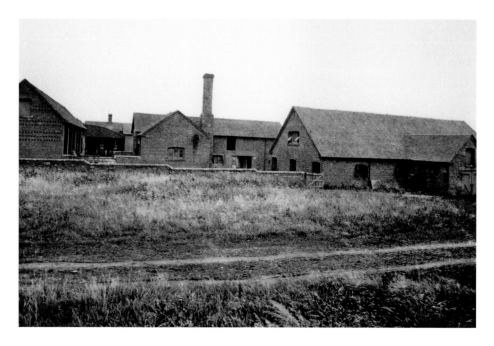

Waste Farm Buildings

The giant Screwfix warehouse was built where the Waste Farm buildings once stood. In 1899, the farmer, Mr Holdcroft, was given notice to quit because Longton Corporation wanted to use the land as a sewage disposal site; treated sewage was to be spread across the farmland. Two steam plough engines were ordered to work the farm. Before they were even delivered, they were requisitioned by the government for the war effort in Africa; £2,000 was paid in compensation. Two more engines were ordered, named *Samson* and *Goliath*.

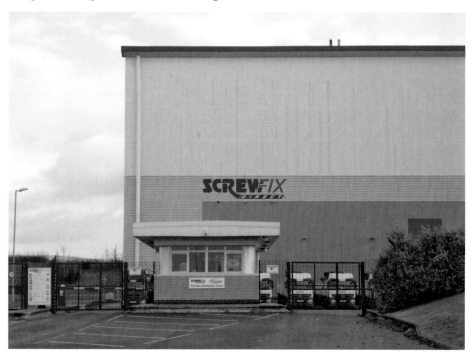

Hem Heath Primary School

Hem Heath Primary School was built in 1956 for the influx of children from the new estate. It was absorbed into the high school complex and known as the tower building. In 2013, it sits forlornly awaiting demolition. The picture was taken from Tilery Lane, where the Waste Farm stood. There is a wonderful clown inlaid on the floor of the reception hall, which has been photographed before it disappears. Kemball Special School will be moving from Duke Street, Fenton, to a new school being built on the site.

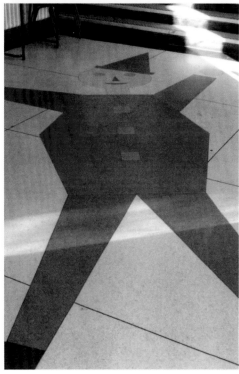

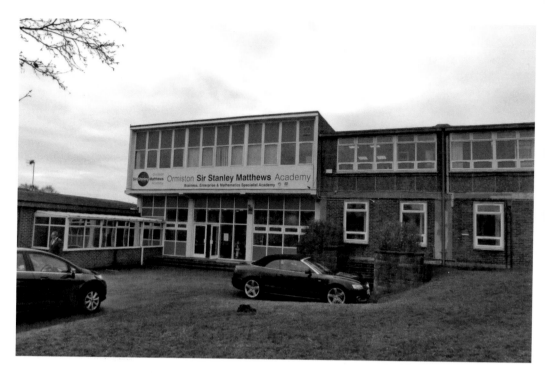

Blurton High School

Blurton Secondary Modern School was also built in 1956, on land formerly belonging to the Waste Farm. It became Blurton High School, and its entrance was on a previously unnamed street, now called Eastwood Close. It closed in 2012 moving to the nearby Ormiston Stanley Matthews Academy. In 1908, 7 acres of land known as Blurton Oaks was cleared and offered for rent at 30 shillings per year to the corporation. The new academy is built on the Blurton Oaks site.

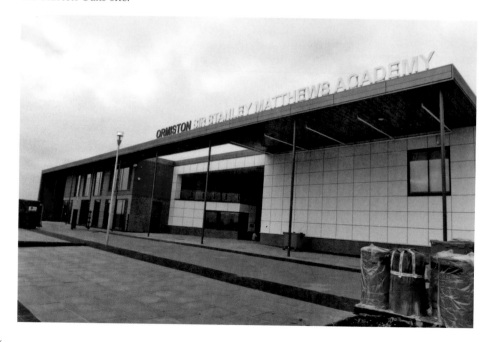

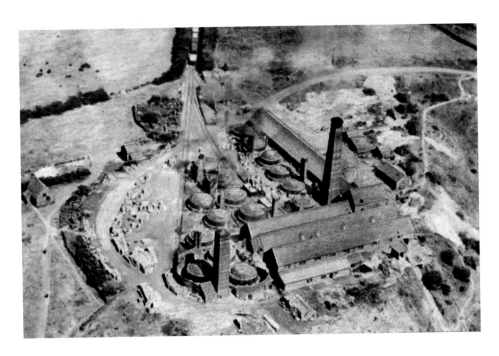

Tilery

Blurton Tilery was established on the curate's land, known as Kemlow, in 1797. There is a natural spring here, which supplied the tilery with crystal water; it still runs into the Longton brook. In 1848, the tilery's order book records that 60,600 bricks were bought and paid for by Issac Legge. St Gregory's School, Spring Garden Road, was built with Blurton Tilery bricks. In 1901, Thomas Tansley took on a new twenty-one-year lease for the tilery. Two German incendiary bombs landed in the marlhole in 1941, intended for Great Fenton Coal & Iron Works. The last manufacturer of tiles here was G. H. Downing. Following the closure of the tilery, the site was used for landfill and eventually grassed over.

Blurton Tilery,

BLURTON, near LONGTON,

STAFFORDSHIRE.

Brick Department.

Usual and Special Descriptions of

BUILDING BRICKS.
PAVING BRICKS.
COPING BRICKS.
TILES—Roofing, Ridging, Garden, &c.
QUARRIES—Flooring, &c.
BLOCKS, QUARRIES, &c., for
Mangers and all requirements for Farm Buildings.

Pipe Department.

SOCKET & PLAIN (Butt Joint)
PIPES, GULLIES, &c.
and All Accessories.

Agricultural Drainage Pipes

of excellent quality and suitability for Land
Improvement and General Estate Work.

Railway Sidings—TRENTHAM, N.S. Rly.
Canal Wharf—HEM HEATH (Trent and Mersey Canal).
Telegrams—"Tansley, Blurton, Longton, Staffs."
Letters to the Manager as above.

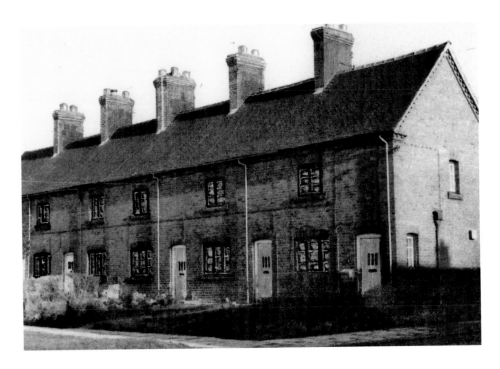

Tilery Cottages

The tilery cottages were built in 1875 to house the workers of the nearby tilery. There was a deep pool where the green area now is in front of Brocton Walk. The tilery cottages are the only terraced row in Blurton. There are six houses, each with its own pigsty, earth closet and small garden, and a shared backyard. Almost lost in the council-house jungle, the cottages are a rare survivor of old Tilery Lane.

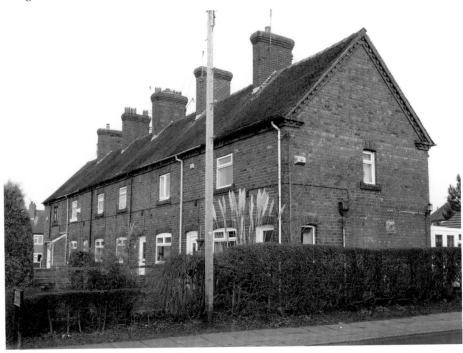

Longton Mill

Longton Mill was without doubt the most ancient building in Blurton. In use from 1250 by Trentham Priory, it was rebuilt in 1290. Originally a corn mill, it was purchased by Revd Obidiah Lane in 1774 and worked as a flint mill. The Longton Brook was diverted to form a leat running along the other side of Poplar Lane to work the waterwheel. The mill has gone and new houses have been built on site, but the Longton Brook still rushes to its destiny.

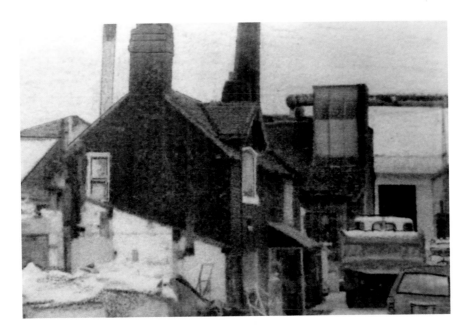

The Bone Mill

In its last years, the mill was used to grind up animal bones and was called Sideway Mill, known to locals as the Bone Mill. From 1920 it was used by British Glue & Chemical Ltd, The picture shows employees receiving long-service awards. They are: Bill Edwards (eight years), John Abel (fourteen years), Reg Clews (forty-six years), Joe Cooper (thirty-two years), Les Warner (thirty-seven years), Walter Buckley (nineteen years), Reg Abel (twenty-one years); it must have been a happy ship. The black office building seen was originally the miller's house.

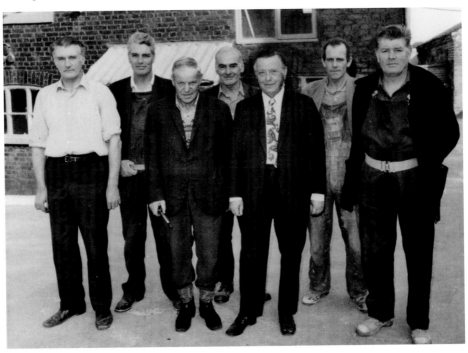

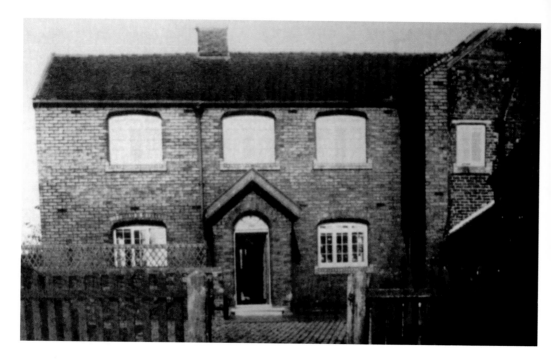

Hollybush Farm

In 1783, Lord Gower exchanged a farm in Longton for Hollybush Farm above, owned by Sir John Edensor Heathcote. Other land was added, and by 1813 it had 175 acres attached. At this date Hollybush Farm was again exchanged back into Sir John Edensor Heathcote's ownership as a result of Lord Gower's land consolidation. The land running down to the Cockster Brook behind the farm was called Broomy Bank. The old farmhouse has been replaced by a substantial modern dwelling.

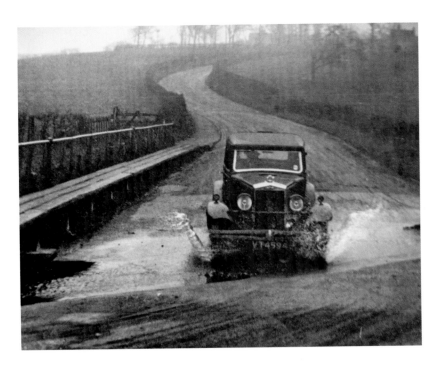

Longton Hall Lane

Longton Hall Lane was an ancient trackway from Longton Hall to the mills at Blurton Meadow, Boothen and Hanford. The ford is pictured above, around 1932. The brook in the dip was dammed to provide ornamental pools for Longton Hall, which sat high above on the hill. It was always prone to flooding, and mist always hung around in the hollow, causing problems for Blurton people travelling up the hill to Fenton. To the right there was a large lake, known as Longton Pool. The culverted brook appears to have been tamed.

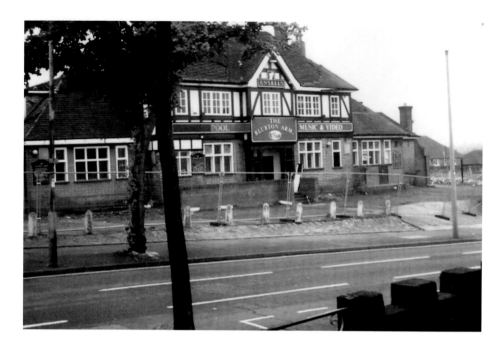

Blurton Arms

The Blurton Arms was a mock-Tudor pub built by Ansells in the mid-1930s to cater for the strangers moving into Blurton from the slum clearance areas of Longton and Fenton. It had a wonderful bowling green behind with a summerhouse overlooking it, a lounge, a smoke room and a bar room. It also had a little outdoor sales window where children, pennies held tightly in hand, would tap and then peer with noses resting on the counter at the selection of sweets and snacks inside.

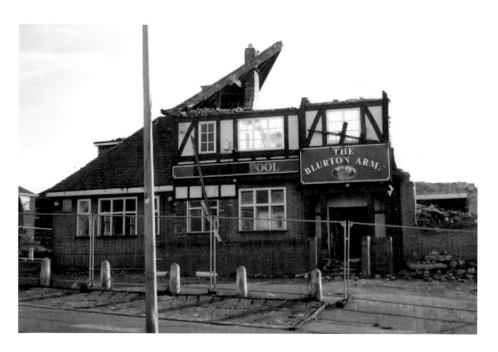

Blurton Arms

The Blurton Arms had roaring open fires and was very welcoming. Unfortunately trade declined due to cheap supermarket booze. It changed its name to Trader Jack's in an attempt to attract the younger drinkers, but with limited success. The pub was razed to the ground and new apartments with romantic Scottish names were built on the site. It is a great loss to locals, who now have only the Blurton Club in which to quench their thirst.

Blurton Green Farm

The open fields of Blurton Green Farm were idyllic, the view only interrupted by National Grid electricity pylons erected in 1930, marching over the landscape like martian machines from *The War of the Worlds*. The farmland was purchased by Ball & Robinson, who built 264 class A3 and 30 class A4 parlour-type houses on it. The area was known as Abyssinia by those who were relocated there from the town in 1936 because it was so far away and had too much fresh air.

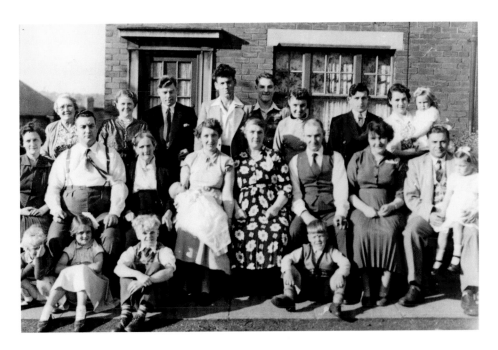

New Arrivals

A family group of first-generation Blurton newcomers sitting outside No. 94 Ballinson Road in around 1953. All of them descended from or married into Emily Knight's family. Son Thomas married Pattie Davis, and daughter Ivy May married Harry Myatt senior. They had arrived from Duke Street, Fenton. Harry was a miner at Great Fenton and Tom became a bookmaker. Men would furtively hand over money and a scrap of paper with a scribbled name at his back door. Ballinson Road is much different today.

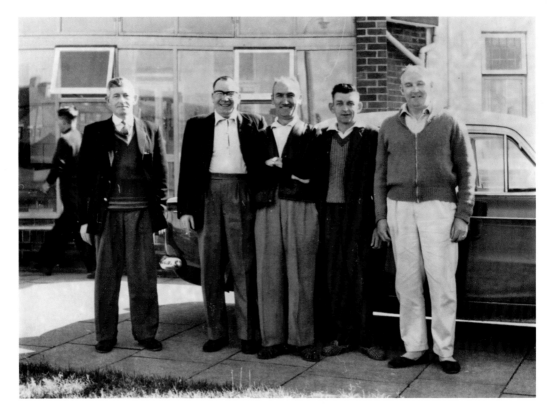

Blurton Miners

A lot of men living in Blurton were miners. A National Coal Board booklet, *The Future of Mining in North Staffordshire*, says: 'In changing times, a man sometimes thinks of moving on, but before pulling up his roots a wise man decides where best to put them down. Where better than the North Staffordshire coalfield.' Sick miners convalesced at the Russell Hotel. These Blurton miners in their carpet slippers in 1964 include Hughie McNally, left, and Harry Myatt, second from the right. The miners received free coal, which was periodically tipped on the pavement outside their house and carried inside with buckets.

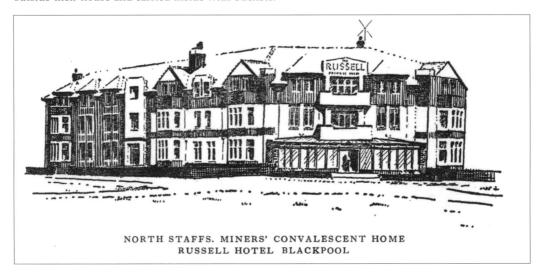

NORTH STAFFS. MINERS' CONVALESCENT HOME
RUSSELL HOTEL BLACKPOOL

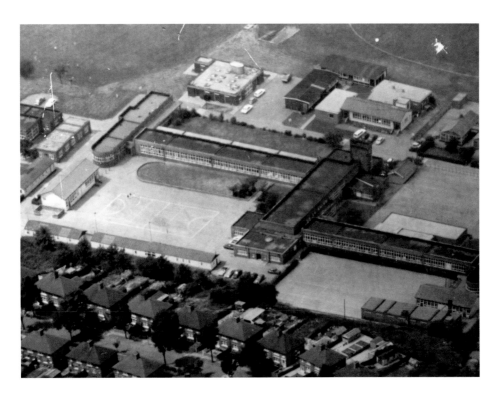

Blurton Primary School

An aerial view of Blurton Primary School, kindly given by headteacher Mrs Price. Building started in 1939 to ease the problem of a growing population, but the outbreak of war caused it to be taken over by the Army; they only left in 1948. The houses along the bottom are Oakwood Road. The infants occupied the left side of the school and juniors the right. The hut at the bottom right was the Navy, Army & Air Force Institute (NAAFI) for the military. The school was rebuilt and opened in January 2003.

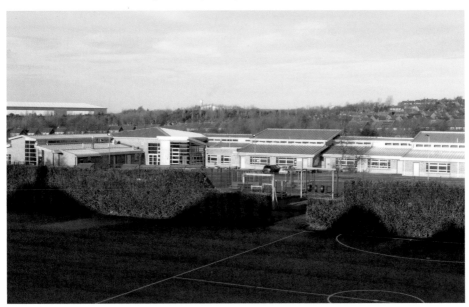

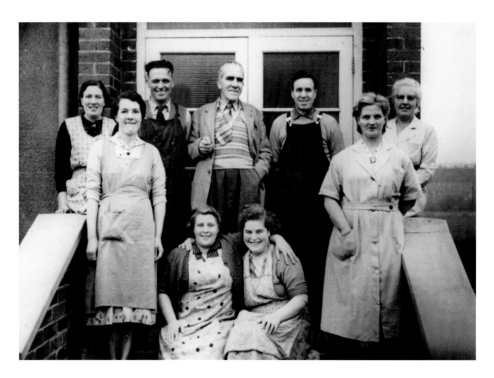

School Cleaners

In the school cleaning team on the entrance steps in the 1950s are, from left to right, back row: Nelly Lane, Bert ?, Mr Eastwood the caretaker (who came from London), -?- , Mrs Eastwood; Front row, standing: Nora Myatt, Marion James; Front row, sitting: -?- , Miriam ?. The cleaners worked before and after school, but in the holidays they worked full-time to spring-clean the building. The new school entrance is shown below.

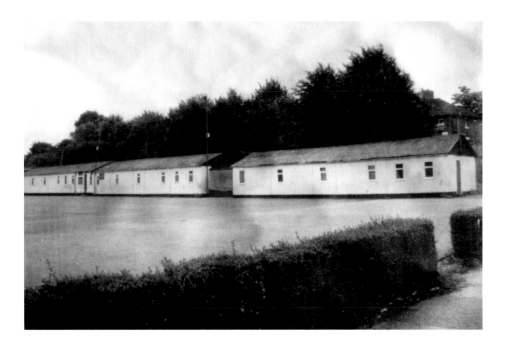

Huts
These three prefabricated huts were erected by the Army in the school playground and left *in situ* when they departed. The junior school put them to use as classrooms. The middle hut was used by Blurton Youth Club along with the old NAAFI. Two further temporary wooden classrooms called the Medway buildings were erected in the playground, with noisy wooden floors which delighted the children. The huts were replaced by Blurton Children's Centre.

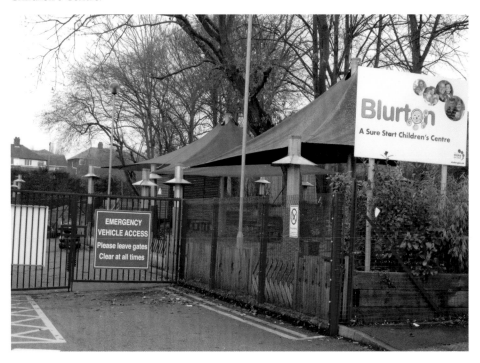

Blurton Shops

John and Imelda Sargeant outside their father's shop in August 1961. There were no shops in Blurton in the early 1900s; people grew their own vegetables and kept chickens and pigs, and milk was fresh from the farms. When the population exploded shops became vital. Someone who saw an opportunity was a cooper from Fenton named Charlie Sargeant. He opened a grocery shop on Blurton Road in the 1930s. Their shop is now rented out to a men's barber.

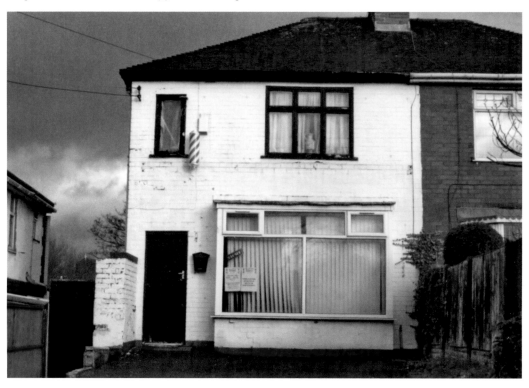

Blurton Shops

Before Sargeant's, speciality goods had to be obtained from the myriad of corner shops, such as Middleton's, seen right. This meant travelling up the lane to town. A new parade of shops was built in the late 1950s, with a new post office run by the Paddocks, a toyshop opened by the Churches family, and a hardware and decorator's shop run by Mrs Cartlidge. The shops agreed not to sell any goods that their neighbours stocked. Today it is cut-throat. The post office is a hub of activity.

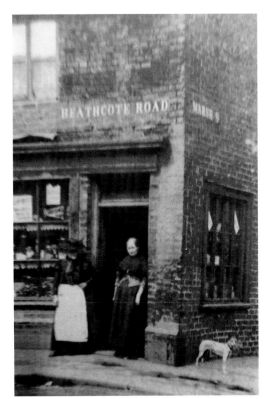

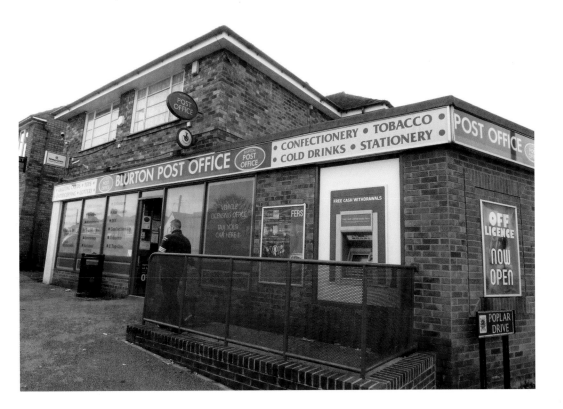

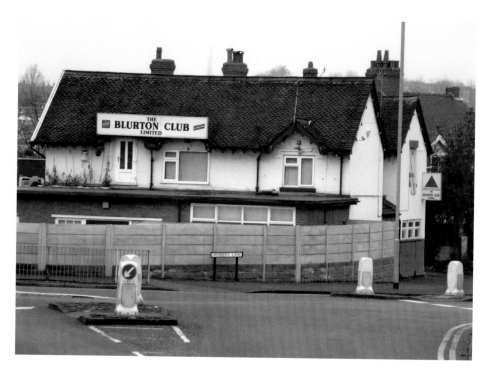

Woodland Cottage

Woodland Cottage was built around 1850 by the Heathcotes of Longton Hall on the edge of their estate. It was surrounded by a small wood with an orchard facing Critchlow's. From 1901 it was home to Robert Hawley, who owned Wellington Works Pot Bank, Flint Street, Longton. His family also had the Union Hotel in Uttoxeter Road. Hawley died at his home in 1938, and it was put up for sale. He is buried at Blurton church facing School Lane. His cottage became Blurton Club Ltd.

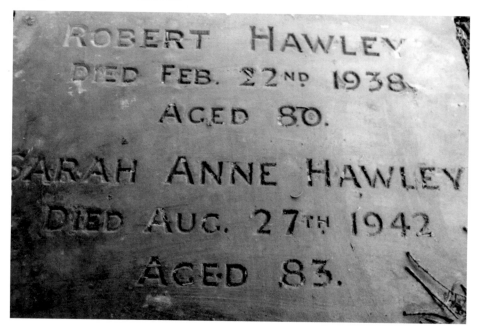

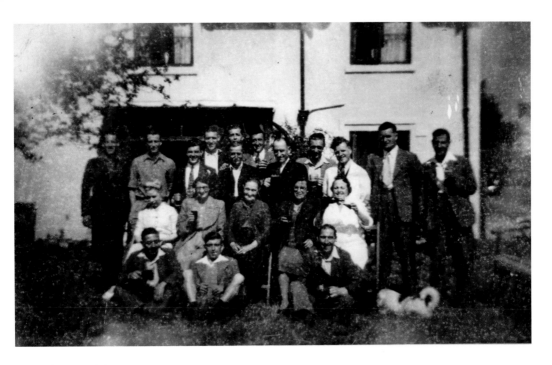

Blurton Club

Blurton Club was trading as a private working men's club soon after Hawley's death. Charlie Sargeant became the first president, a post he held for many years. During the war, the club was used as an Air Raid Precautions station. Some of its founder members are seen here enjoying a drink in the orchard in the 1950s. Young Harry Myatt appears to be getting a leg tan. The two boys fronting are David and Karl Knapper. Many well-known artists appeared at the club, including Jackie Trent, Jimmy Jewel and Anne Shelton's sister Jo Shelton.

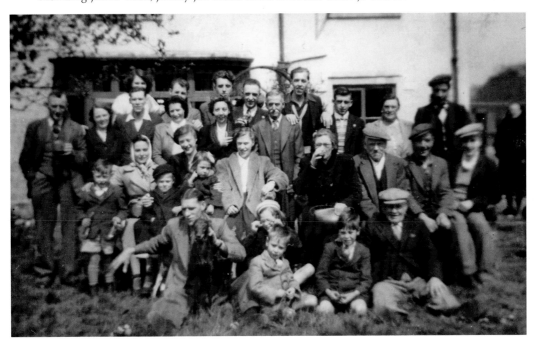

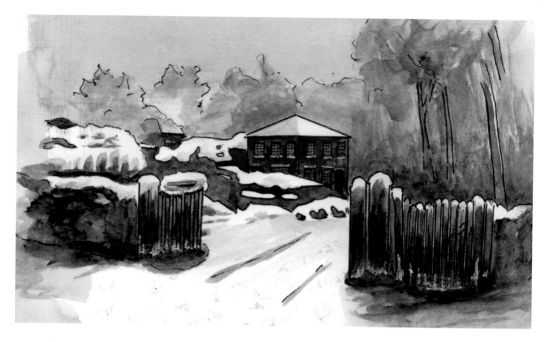

Blurton Cottage

This watercolour was taken from a very old image of Blurton Cottage in the snow. It was a large house located near the footbridge over the brook at Goms Mill. In 1851 it was occupied by William Kenwright Harvey, who owned Harvey's Pot Bank in Longton. His servant Thomas Woolley lived in the adjacent cottage. Harvey's had its own bank; it failed in 1866 and W. K. Harvey fled to America with £400 in gold. A small estate has been built on the site of Blurton Cottage.

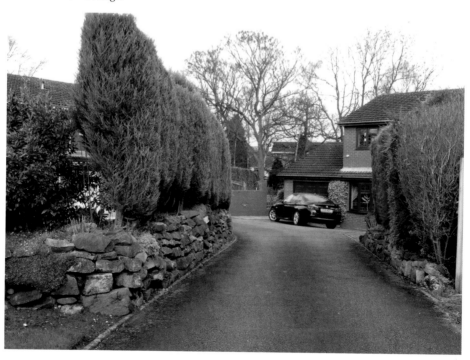

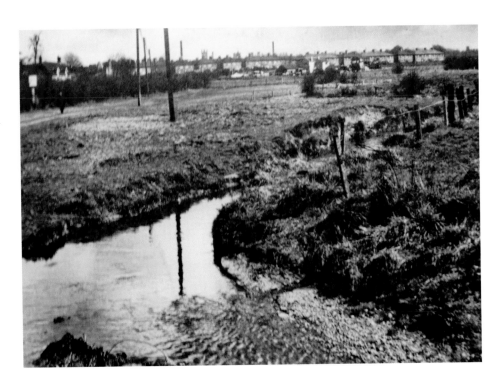

Goms Mill

A photograph of Longton Brook, taken from the footbridge at Goms Mill in 1953. It was a fast-flowing stream that began life at the springs in Normacot and fed the Upper and Lower Goms Mills. The lower mill was built in 1595. In 1632 it was leased to Sampson Gomm for two lives. His name is still in use 380 years later. Rays Farm, on the left, was found to be an old timber-framed building when it was demolished. The stream is now narrower.

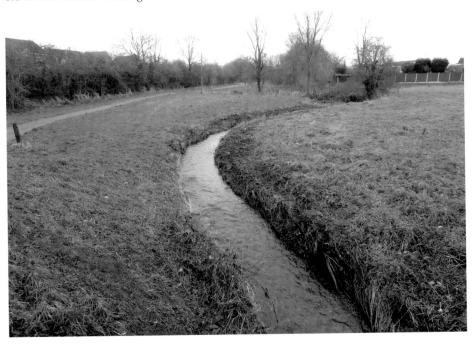

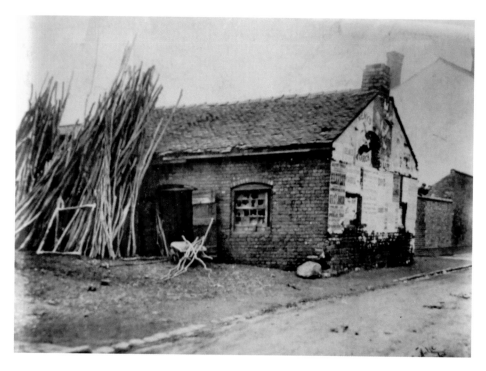

Goms Mill

Every household in Blurton needed a line prop to raise their clothes line – there were no metal ones in the old days. Everyone called at the rustic yard at Goms Mill to purchase one. It is still working today, making rustic birdhouses and garden seats. The photograph was given by Joe, the present occupier. At the bottom is written Longton Infants, 1866; was it built as or adapted to be a school?

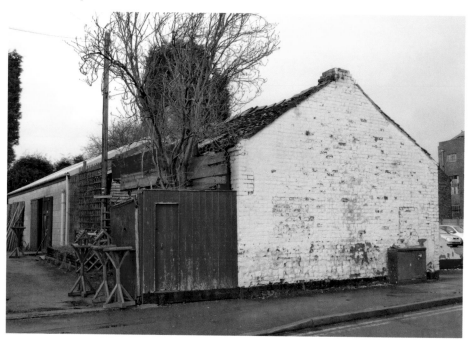

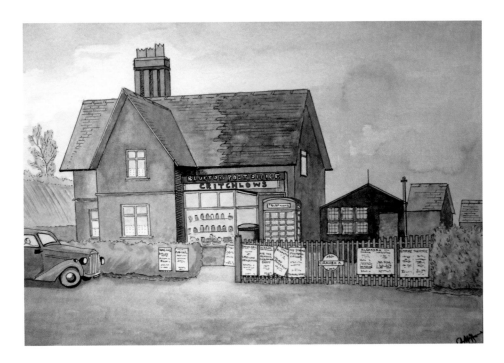

Fingerpost Cottage

Fingerpost Cottage was home to the Critchlows, who came from Cellarhead in 1895. In 1936 the cottage was extended to include a newly opened post office and shop, as can be seen from the tiles. Outside were posted PMT bus timetables and a village telephone box – at a time when telephones were a novelty. The shop sold sweets and a few essentials. The post office is now a house, and new houses have been built on Arthur Critchlow's extensive garden, where sunflowers always nodded over the hedge.

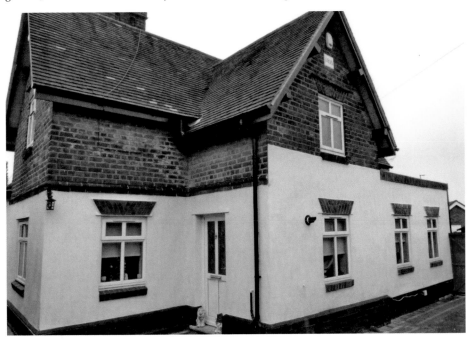

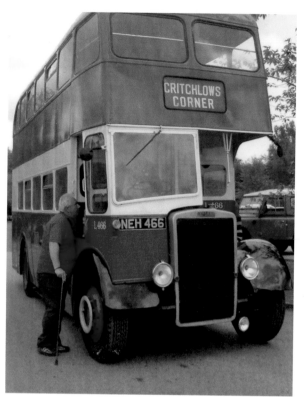

Critchlows Corner Buses

Double-deckers displaying 'Critchlows Corner' on the board were once a familiar sight. Even today, people ask the bus to stop at Critchlows, but the display only says Blurton. Potteries Electronic Traction (PET) buses first came through Blurton in 1925, to convey workers to Taylor & Tunnicliffe at Stone. Proctor's purchased an old PET bus and started a local service, Tollgate to Longton, which ran six days a week with tickets costing 1s 3d per week. If a regular passenger was late the driver would wait for them – there were no timetables in those days!

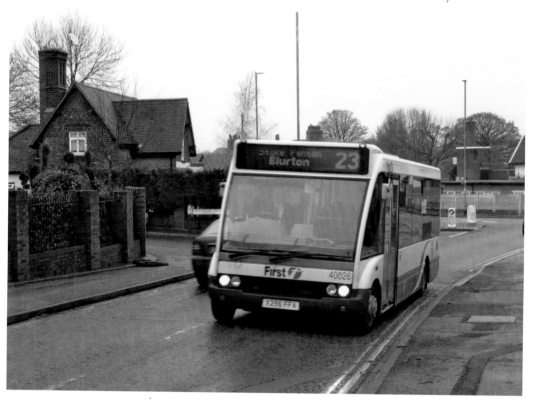

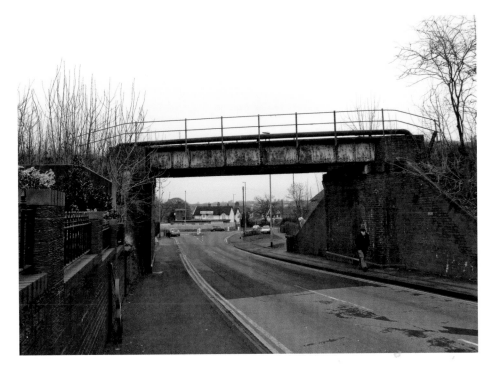

Railway Bridge

The days are numbered for this old railway bridge at Critchlows Corner, which has been out of use since 1979. The mineral railway was constructed in 1879 to convey coal from Florence Colliery to Hem Heath sidings. A spur line left at Ballinson Road and led to Blurton Tilery. There is another bridge over Trentham Road, which was designed to be raised up by machinery to allow the passage of high vehicles beneath it. The railway track was taken up for scrap.

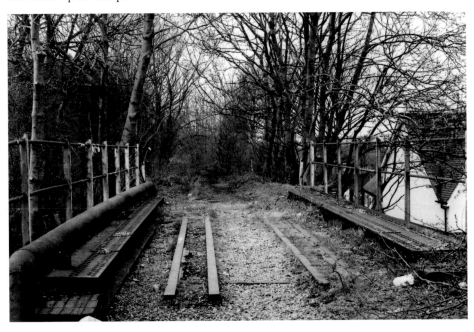

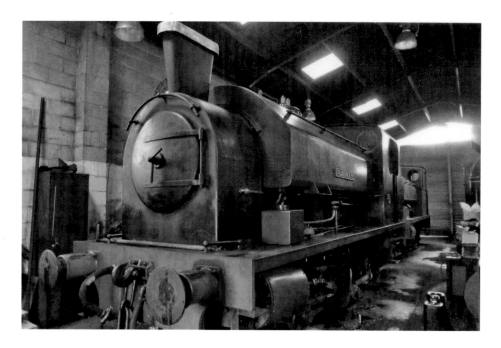

Mineral Railway

The duke had his own engine working the line in 1882. This Bagnall 0-6-0 saddle tank engine, built in 1954, was one of a batch supplied to the NCB in the North Staffordshire area. It worked the 2-mile stretch of line through Blurton. Its name is *Florence II* and it joined an identical engine at Florence known as No. 1. Retired in 1978, it has been rescued by Dave Donkin of Newstead, and after extensive repairs it runs regularly at the Foxfield Railway Museum, Blythe Bridge.

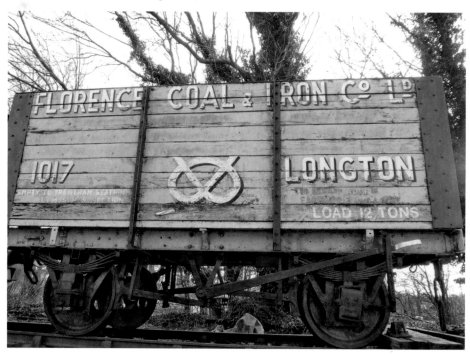

Street Signs

Two interesting old street signs: The first is at Heron Cross on yellow brickwork over the chemist. This was the site of Heron Cottage, home to Charles Mason who owned Minerva China Works. Wrecked by Chartist rioters in 1842, it was replaced with terraced shops. It had extensive gardens running along Duke Street. The second is a cast-iron sign at Normacot, but notice the addition of the extra 't'; could it be reference to 'Norsemans Cottage'?

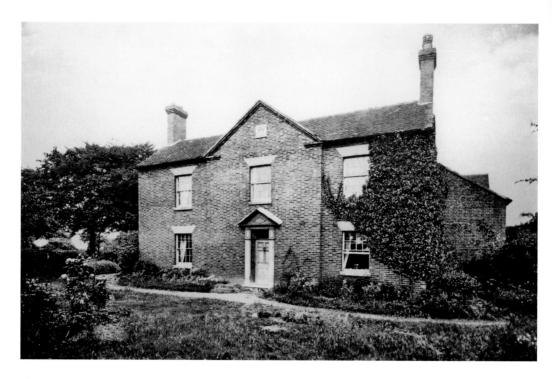

Blurton Green Farmhouse

The farmhouse used to stand on the opposite side of the road. This replacement was built by the Marquis of Stafford and had a datestone of 1839. It farmed 113 acres, including the Oakwood Road area. It was Blurton's vicarage from 1921 until 1927, when the new vicarage was built in School Lane. It then became Joe Lawton's riding school until it was demolished and new bungalows were built on the site.

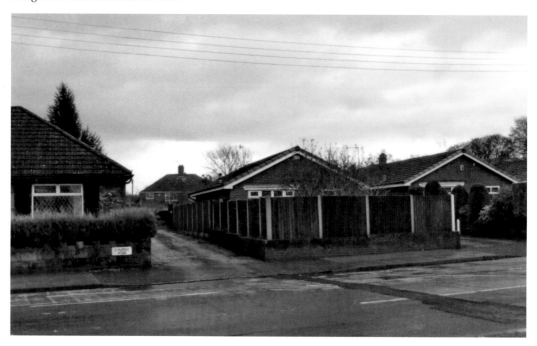

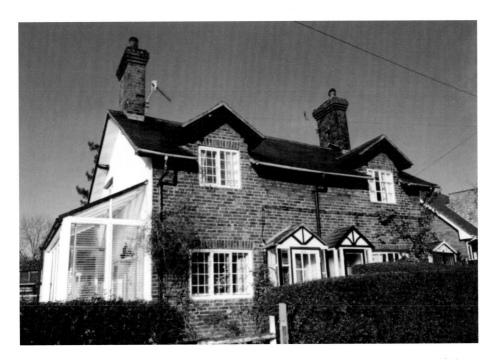

Spartans

The old cottages pictured appear to have been built in the early 1700s. They are tiny cottages and were once home to one of the Wright family from Tollgate. The cottage on the left has been renovated and a new house built on its garden. Opposite is the Gables pub, where once stood three large houses called the Spartans, which had a private tennis court. The lane was called Meadow Lane. It once led to Cocknage, but now it is blocked up.

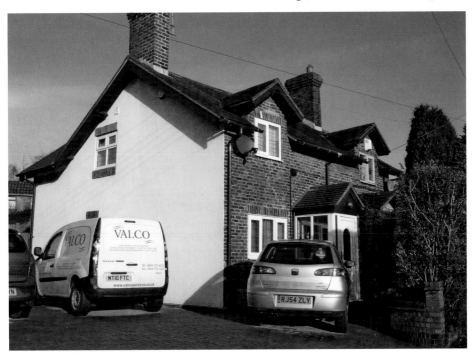

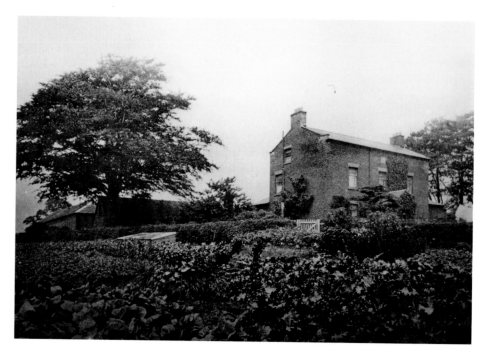

Blurton Grange Farm

Blurton Grange Farm used to stand on the corner of School Lane, where two bungalows are now sited. The farm gatepost is still there. The Grange was demolished in 1832, being rebuilt up the lane opposite with a datestone of 1817. The village pound was on the corner of the new farm lane, where wandering cattle were kept awaiting collection. The railway line detached part of the farm's 255 acres, so a tunnel was constructed to allow access to these fields, now occupied by the park.

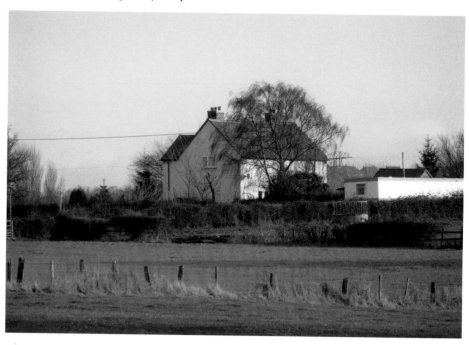

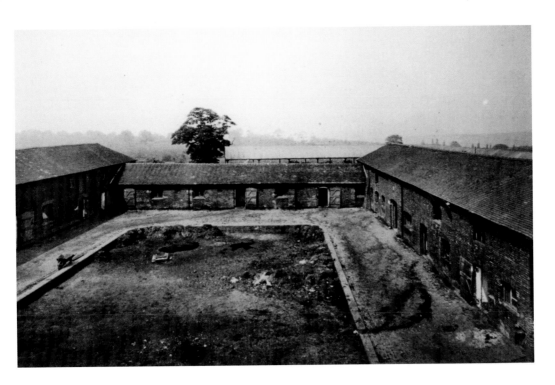

Grange Farm Buildings

The Grange Farm buildings were built in a square to allow the farmer to observe all activity there. They have all disappeared, replaced by modern sheds. A footpath runs right through the farm up to Cocknage, over several styles and through very muddy conditions, much to the annoyance of the farmer. If this footpath is not kept in use there is danger it could be lost forever.

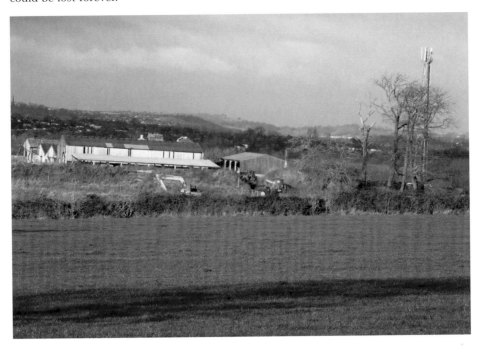

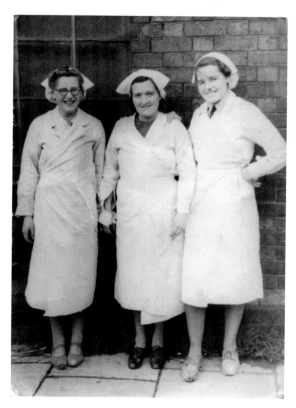

Girls from the Potteries
Pottery girls from the clay end at Barker Bros, in 1942. They are Annie Parker, Liz Harding and Doris Bentley. They were all workmates of Nora Carr, who met her future husband on the third row of the Alexandre picture palace. She was with her sister Mary and Dolly Fenton, and afterwards they went to the Studio Milk Bar. Her last job was at Shore & Coggins – now Glebe Engineering Ltd, which makes high-precision machine parts.

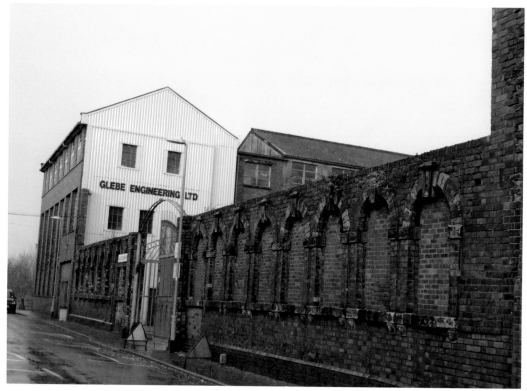

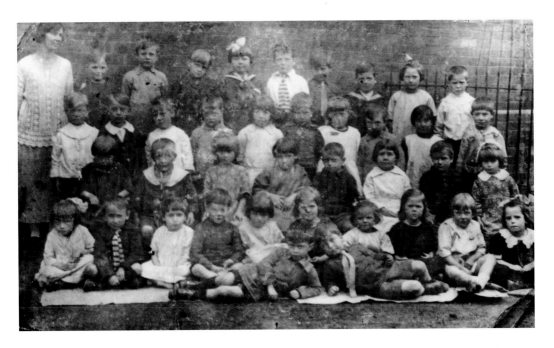

Dresden School

A picture of Dresden schoolchildren in 1930. Nora Carr stands at the back – she is second from the right, with a ribbon in her hair. Her parents lived in a two-bedroom terraced house in Cobden Street. They had twelve children, and a married couple lodged with them. They slept in the same room, with a blanket over a rope to separate the families. The Furnace Brook ran through Dresden school playground before disappearing underground to Goms Mill. A new school has been built on the old Florence Colliery site, and Belgrave Road School is abandoned.

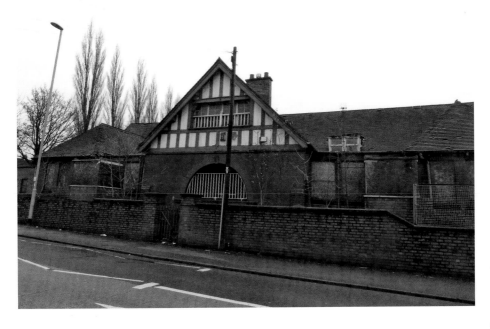

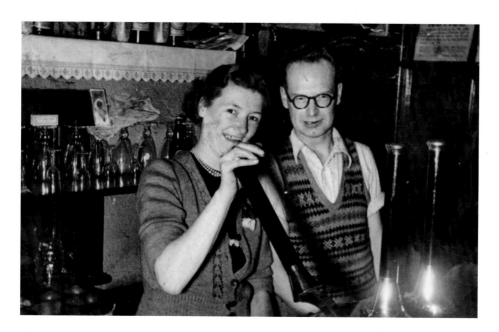

Sailor Boy

The eldest of the Carr children was Marjorie. She went to work in service at Tittensor, where she walked to work over the fields, a distance of 3 miles. She met a young airman from the RAF named Colin Swift, and when they married they took over his father's pub, the Sailor Boy Inn, Uttoxeter Road, where they remained for the rest of their life. Marjorie's day off was spent up the road at her friend's pub, the Rose Inn. The Sailor Boy later became work units.

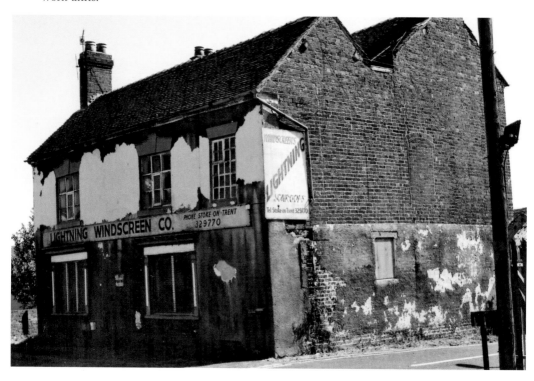

Thomas Brookfield

Thomas Brookfield on his Hill Hurberry Cooper cycle. It was a Kangaroo type, made in Coventry in 1885 and now on display at the National Cycle Museum, Temple Street, Llandrindod Wells. He was known for fitting petrol engines onto cycles, and also for buying chassis onto which he built car bodies. He acquired Nos 36, 38, 40, 42 and 44 Trentham Road. In 1915 he was riding one of his contraptions at Ash Green when the gears jammed and, according to the newspaper, 'he fell on his head'. The accident killed him.

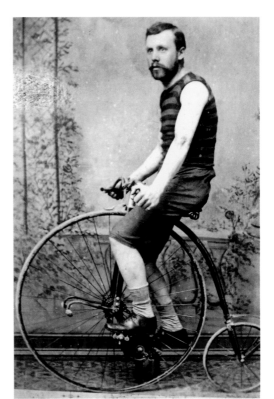

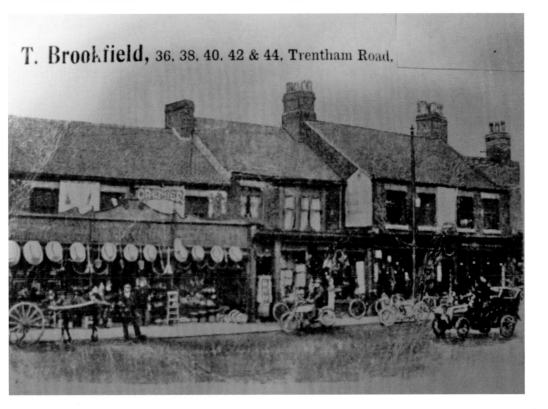

T. Brookfield, 36, 38, 40, 42 & 44, Trentham Road,

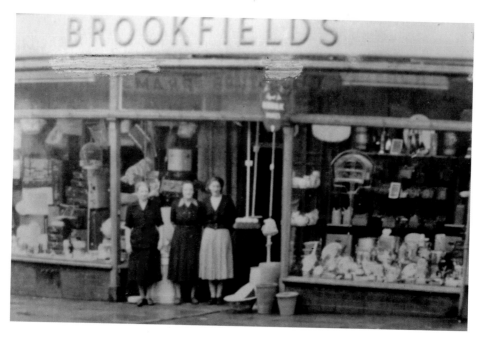

Brookfields

The previous picture showed Brookfields' property around 1900. Thomas had started in business 1888. During the war, engine parts became scarce, and instead the shop was stocked with prams and bicycles. This change of tack proved so successful that they progressed into selling toys. Every child in Blurton has stood with their nose pressed on the window, dreaming. Above, Mrs Brookfield, Mrs Kendall and Miss Jean Mills are pictured in the 1960s. Brookfields is still trading in the capable hands of Jonathon Dutton and his wife Jill.

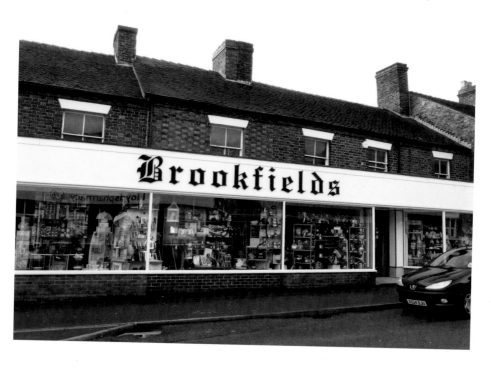

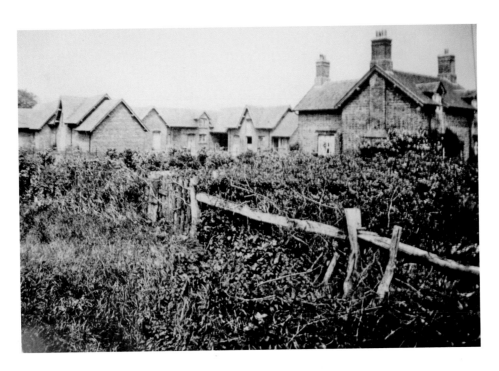

Windy Arbour

In 1919 this was a small farm called Windy Arbour on Cocknage Road with 52 acres of land. A gravestone in Blurton churchyard states: 'In this grave lie the children of William and Mary Lea of Windy Arbour, Blurton. Daughter Mary died November 25th 1842, aged 20, but twice absent in 14 years from the church she loved.' The waste tip of Florence Colliery crept ever closer and the farm was abandoned. Today it is just a leafy corner on a sharp bend.

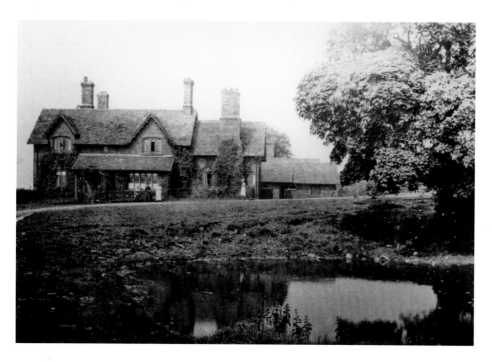

Cophurst Farm

Cophurst Farm was far out from Blurton village, but still lay within the parish. It was important because it was the only other brickworks in Blurton. Seen above in 1919, it was sold with 77 acres and an excellent seam of red quarry clay. The tenant was Charles Benbow. There was a rifle range between Cophurst and Coldriding in 1890. The barns have been converted into homes, and the quarry was taken over by Daniel Platt in 1991. Today the heavy lorries still cause problems for the locals.

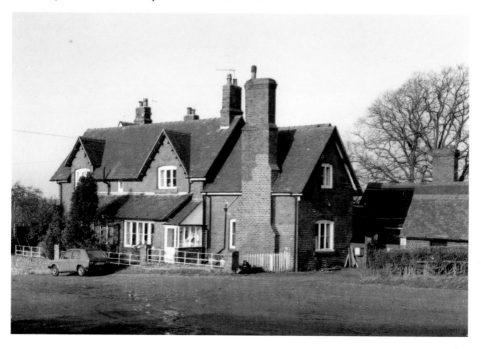

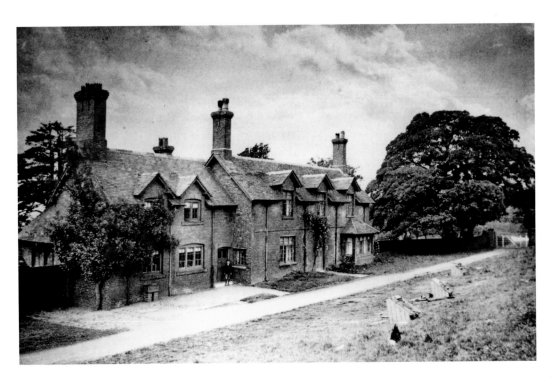

South Cocknage Farm

In 1919 South Cocknage Farm was described as a superior grazing and feeding farm with 65 acres of land. It had six bedrooms and a man's bedroom. The cowhouse had tying for forty-one cattle and six pigstyes, the land was deep, rich loam. The tenant was John Dale. The farm has extensive views over Blurton and Trentham. Today a large part of the farmhouse has been removed, Incidentally, *Cocknage* is Old English meaning 'land of delight'.

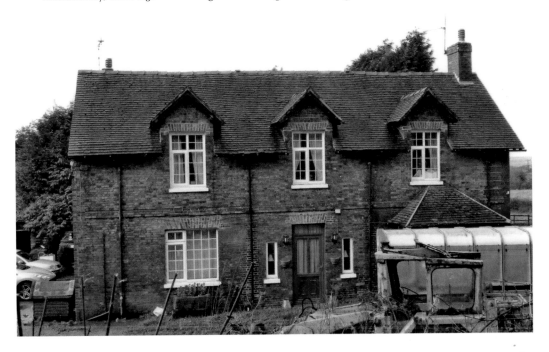

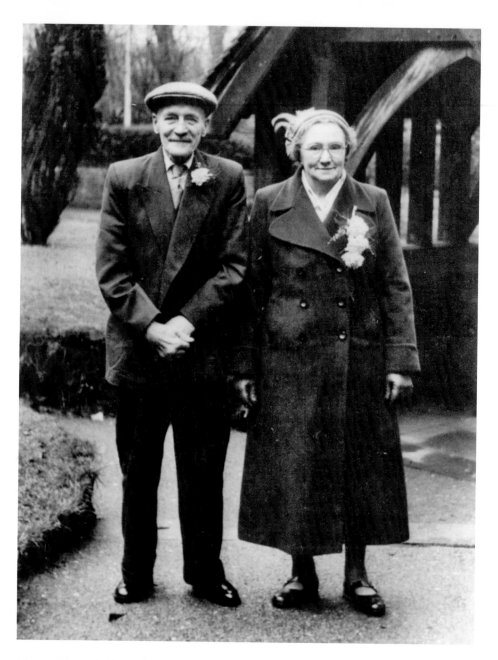

Blurton Through Time: **The End**

The misty-eyed story of *Blurton Through Time* ends with this loving couple, pictured at Blurton church in 1955. Ernest Carr from Rose Cottage was a Blurton church choirboy. He received a diamond commemoration bible from Blurton Sunday school for ninety-six attendances during the year 1897. Olive Tomlinson from Crown Cottage had played in the lanes with Ernest, and they attended the church school together. Can you imagine this sweet old lady receiving the cane for playing late in the lane when she should have been in school? Olive's family moved to Oulton due to her father's work, and she was pursued by Ernest who married her in July 1916. They remained devoted to one another all their life, until they passed away in 1962 and 1963.